IMAGES
of Rail

PENNSYLVANIA MAIN
LINE RAILROAD STATIONS
PHILADELPHIA TO HARRISBURG

Pennsylvania Main Line Railroad Stations, Philadelphia to Harrisburg
with mileposts

County	Area	Milepost	Station
Philadelphia	Center City Stations		The first passenger stations in Center City were accessed by non-locomotive connections from across the Schuylkill River at the railroad's terminations. These included Broad and Vine (P&C), 8th & Market, and 18th & Market.
			Broad Street (1881-1952)
			Suburban (opened 1930)
	30th Street Area		31st and Market (1864-1876)
			Centennial/32nd and Market (1876-1896)
			West Philadelphia (1903-1933)
			30th Street Station (opened 1930-1933)
		1.4	Powelton Avenue
		2.0	Mantua (35th Street)
		2.6	40th Street
		3.1	Girard Avenue
		4.1	52nd Street (Hestonville)
		5.6	Overbrook (City Line)
Montgomery County		6.1	Merion
		7.0	Narberth (Elm, Libertyville)
		7.6	Wynnewood (Wynne Wood)
		8.6	Ardmore (Athensville)
		9.3	Haverford (Haverford College)
		10.3	Bryn Mawr
			Whitehall (on old alignment)
		11.0	Rosemont
		11.7	County Line
Delaware Cty.		12.1	Villanova (Villa Nova)
		12.5	Upton (Radnor)
		13.1	Radnor (Brookeville, Morgans Corners)
		13.9	St. Davids (East Wayne)
		14.6	Wayne (Louella)
Chester County		15.5	Strafford
		16.0	Eagle (Eagle Hotel)
		16.6	Devon
		17.7	Berwyn (Reeseville)
		18.7	Daylesford
		20.0	Paoli
		21.1	Green Tree (Duffryn Mawr)
		21.7	Malvern (West Chester Intersection)
		24.0	Frazer (Garretts Siding)
		25.5	Glen Loch (Steamboat)
		26.8	Ship Road
		27.5	Exton (Whiteland, Walkertown)
Chester County (cont.)		28.5	Whitford (Oakland)
		29.9	Bradford Hills (Valley Creek)
		31.2	Woodbine
		32.6	Downingtown
		33.9	Gallagherville
		34.8	Thorndale (former PRR)
		35.2	Thorndale (current SEPTA)
		36.8	Caln
		38.6	Coatesville
		39.9	Midway
		42.3	Pomeroy (Chandlers)
		44.3	Parkesburg (Fountain Inn)
		45.7	Lenover
		47.1	Atglen (Penningtonville)
Lancaster County		48.5	Christiana (Noblesville)
		51.1	Gap (The Gap)
		53.8	Kinzer (Kinzers)
		56.5	Leaman Place (Lemans)
		58.0	Gordonville (Paradise)
		60.0	Ronks (Ronk)
		61.1	Bird in Hand (Enterprise)
		62.7	Witmer
		68.1	Lancaster
			Dillersville (on old alignment)
		71.7	Hempfield
		75.4	Landisville
		76.1	Salunga
		80.1	Mount Joy
		81.3	Florin (Springville)
		84.1	Rheems
		86.9	Elizabethtown
		89.3	Conewago
Dauphin County		91.6	Hillsdale
		93.5	Branch Intersection
		94.0	Royalton
		94.4	Middletown
		96.2	White House
		97.7	Highspire
		100.0	Docklow
		101.2	Steelton (Baldwin)
		102.3	Lochiel
		103.9	Harrisburg

There have been more than 80 station locations at one time or another between Philadelphia and Harrisburg since the first trains started running in the 1830s, though a precise number is difficult to determine due to station relocations and track realignments. At its peak in the early 1900s, one could travel to nearly 60 different locations along the Main Line. Today, that number is 31. This is a listing of the stations by county, in order from east to west. A station that is indented no longer exists or, if the station building still stands, trains no longer stop there. Official (or unofficial) names or spellings for the stations are in parentheses. Places that have had more than one station location, such as Lancaster City, only include the latest location.

ON THE COVER: The photographer was standing on the Railway Express platform at Downingtown when he captured this shot of a westbound Pennsylvania Railroad train pulled by a GG1 locomotive. Two men with a large cart loaded with boxes and one with a smaller cart with mail pouches try to make their way to an open door on the train. The crowd meeting the train was quite large and extended the length of the platform and back to Lancaster Avenue on the left. Unfortunately, further research has not been able to identify the event that captured the attention of so many in Downingtown on this warm afternoon in 1941. (Courtesy of Downingtown Area Historical Society.)

IMAGES
of Rail

PENNSYLVANIA MAIN
LINE RAILROAD STATIONS

PHILADELPHIA TO HARRISBURG

Jim Sundman

ARCADIA
PUBLISHING

Published by Arcadia Publishing
Charleston, South Carolina

Printed in the United States of America

Library of Congress Control Number: 2015959090

For all general information, please contact Arcadia Publishing:
Telephone 843-853-2070
Fax 843-853-0044
E-mail sales@arcadiapublishing.com
For customer service and orders:
Toll-Free 1-888-313-2665

Visit us on the Internet at www.arcadiapublishing.com

To my parents, Rodney and Eleanor Sundman. All those trips to historic places we took growing up instilled in me a great love for history.

CONTENTS

ACKNOWLEDGMENTS

When this project started, I did not realize how many people and institutions I would have contact with that would provide images and information for this book. I would like to specifically thank the following for their valuable contributions: Downingtown Area Historical Society, Chester County Historical Society, Graystone Society in Coatesville, Lancaster County Historical Society, Hagley Museum and Library, Highspire Historical Society, Amtrak Engineering Archives, Historical Society of Pennsylvania, Caln Township Historical Society, Tredyffrin Easttown Historical Society, Lower Merion Historical Society, Library Company of Philadelphia, Temple University Library and Archives, Villanova University Archives, Sadsbury Township Historical Society, and Haverford College Special Collections. The Library of Congress also had valuable images in its collections.

There are individuals who I would like to particularly thank for their help: My coworker Karen Seibert, who helped proof the text and offered helpful suggestions; Carol Grigson at the Downingtown Area Historical Society, who volunteered her time to go through the society's photographs with me; Eugene DiOrio at the Graystone Society in Coatesville, who provided some excellent images and wonderful stories on his Pennsylvania Railroad travels; Pam Powell, photo archivist at the Chester County Historical Society; Jim Richter and Maureen McCloskey in Amtrak's Engineering Department; Tom Young, whose grandfather was the station agent at Glen Loch; and Larry Light, a 50-year railroader and a walking Pennsylvania Railroad encyclopedia, who had answers for all my questions as we chatted on the train home. I also want to thank Parry Desmond (president of the Downingtown Area Historical Society) and Phil Dague ("Mr. Downingtown") for their interest in and encouragement of this project. And lastly, my title manager at Arcadia, Liz Gurley, who guided this project along and made this a very enjoyable first-time publishing experience.

Finally, I would like to thank my wife, Beth, and daughters Alexandra, Bethany Rineer (with husband, Ian), Brynne (especially for lending me her camera), Audrie, and Callie for their encouragement and support.

Unless otherwise noted, all images are from the collection of the author.

INTRODUCTION

The Pennsylvania Main Line traces its origins back to the Main Line of Public Works, a railroad and canal system stretching across the southern part of the state between Philadelphia and Pittsburgh. Constructed between 1828 and 1834, the state-built system was intended to compete with New York and Maryland and their respective transportation systems for commercial transport to the west. The works consisted of, from east to west, the Philadelphia and Columbia (P&C) Railroad between Philadelphia and Columbia on the Susquehanna River, the Eastern and Juniata Divisions of the Pennsylvania Canal between Columbia and Hollidaysburg, the Allegheny Portage Railroad between Hollidaysburg and Johnstown, and the Western Division of the Pennsylvania Canal between Johnstown and Pittsburgh.

The system was owned and operated by the Commonwealth of Pennsylvania and was not only financially difficult to build and maintain, but also failed to attract competitive traffic to the west. A trip on the railroad-canal system was slow and often arduous. At both ends of the P&C Railroad were inclined planes where, due to the steep topography, train cars had to be raised or lowered on short sections of track. Both planes were costly to operate and added delays and inconvenience to travelers and the transport of goods. In addition, the canal sections in the western part of the state were often closed by ice during winter months and could succumb to flooding during the spring or even lack of water during dry periods.

Soon after the first trains started operating on the P&C in 1834, the state looked to eliminate the inclined planes to speed up transport and reduce costs. In 1840, the western plane at Columbia on the Susquehanna River was abandoned after a new section of track opened. In 1850, the Schuylkill (or Belmont) plane was abandoned after the opening of the West Philadelphia Railroad. The West Philadelphia Railroad was incorporated in 1835 to build a line between what is now Ardmore and the Schuylkill River in West Philadelphia, but the project was not completed. In 1850, the state purchased the railroad and completed the line to the Market Street Bridge approximately where Philadelphia's Thirtieth Street Station is today.

Despite some improvements to the system during the first two decades of operation, the Main Line of Public Works was nevertheless unprofitable and the state legislature authorized its sale. In 1857, the works were sold by the state to the Pennsylvania Railroad Company (PRR) for $7,500,000. The PRR was the only bidder. The 82-mile P&C Railroad was the only piece of property that was of substantial value to the PRR. The PRR had been incorporated in 1846 under a special act of the Pennsylvania General Assembly in order to construct a railroad between Harrisburg and Pittsburgh. With the addition of the P&C, and with a contract to operate on a privately owned line between Lancaster and Harrisburg, the PRR had an all-rail route from Philadelphia to Pittsburgh.

Immediately after the PRR took possession of the P&C, it began to make substantial improvements to the line. New stations were constructed, much of the line west of Ardmore was rebuilt, curves were straightened, grades changed, wooden bridges were replaced with masonry or steel bridges, and eventually third and fourth tracks were added. In time, the section of the old P&C between Lancaster and Columbia was used less in favor of the line between Lancaster and Harrisburg, which the PRR eventually acquired outright. This line between Philadelphia and Harrisburg was known as the Philadelphia Division, but the "official" PRR Main Line extended to Pittsburgh and beyond.

It was a profitable freight route, but the railroad sought to capitalize on the Main Line by creating additional passenger demand to some of the beautiful locations along the line, especially in the

western suburbs of Philadelphia. Hotels and resorts for summer use were built along the railroad to attract Philadelphians and therefore more train trips. To make these locations more appealing, names of old towns and villages were changed to stops such as Ardmore, Bryn Mawr, Narberth, Radnor, and Berwyn. As these areas flourished, developers sought to attract these Philadelphians to live there year-round and use the railroad to commute to work in the city on a daily basis.

But a major problem that inhibited passenger growth at first was the PRR's (as well as other railroads') inability to provide direct train access to Center City Philadelphia. A city charter prevented the use of steam locomotives in the downtown area. In the case of the PRR on the Main Line, the company could only run its trains as far as the west bank of the Schuylkill River in West Philadelphia. From these terminals, passengers and freight were brought into Center City by other means, such as horse-drawn streetcars. Because of this problem, the western suburbs lacked the growth the PRR wanted to see. This all changed when Broad Street Station directly across from Philadelphia City Hall opened in 1881. Trains could now bring passengers via an elevated line right into downtown. An article in the *Philadelphia Times* in 1882 describes this:

> There has been a most remarkable increase this year, and especially during the past few months, in the local travel on the Pennsylvania Railroad . . . the number of daily trains leaving the Central Station, at Broad Street, has been increased; cars have been added to trains, and even with the greater accommodations it sometimes happens that every seat is occupied. Men engaged in business enterprises, manufacturing projects and professional duties who have been debarred from the pleasure of suburban homes until the completion of the elevated extension to Broad and Market streets, because of the time lost in getting to and from their places of business, have been enabled to provide themselves with cottages and gardens, villas and lawns, and dainty country nooks for their families, brought so close by the railroad company's enterprise that they can get to their offices quicker than they used to do in the street cars from West Philadelphia.

Broad Street Station saw such a rapid increase in passenger traffic that it was expanded a decade later, including a massive new train shed that covered 16 tracks—the largest train shed in the world at the time. Broad Street Station was an architectural masterpiece, but the PRR also built beautiful stations along the Main Line as well. From the 1870s through the 1890s, most of the original stations along the Main Line were replaced by larger, more ornate structures. Even the small towns and villages in the far western communities of Chester and Lancaster Counties (where the first stations were often wayside inns) were recipients of fine station buildings.

As time went on, many of these old structures—especially in rural areas—saw declining passenger use, which led to their closure and subsequent demolition. Others remained open, but the changing needs of the traveling public along with the cost to maintain these structures often led to their replacement, usually with utilitarian but functional stations. Sadly, a few burned down. Some, however, still stand, often because the local community saw the importance of keeping these buildings even though they may not be functional for railroad use.

The purpose of this book is to provide a glimpse of these stations along the Main Line, not only the Main Line in the "social sense," which traditionally ended at Paoli in eastern Chester County, but also west to Harrisburg. The book begins in Center City, which is milepost zero, covers the stations at or near the Thirtieth Street area of the city, then follows the railroad west through West Philadelphia, wealthy suburban communities, small industrial towns, and rural villages, and ends at the state capital of Harrisburg (a distance of about 100 miles). Historical photographs document many of these structures, but some modern-day images are included to give a compelling before-and-after look at these locations. Additional images document the workers and functions associated with these stations. Ideally, the author would have liked to include images of all stations along the Main Line, but in some cases none could be found or those that did exist were of poor quality. Hopefully, however, the images and associated descriptions here will help the reader better understand and appreciate the old Main Line.

One

THE PHILADELPHIA AND COLUMBIA RAILROAD

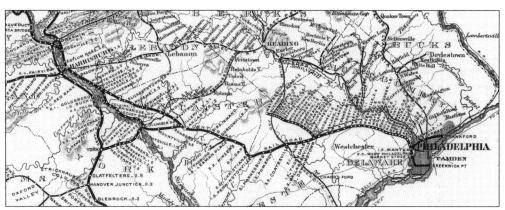

The original rail portion of the Main Line was part of a state-owned system and ran 82 miles from Philadelphia to Columbia on the Susquehanna River. The first through train ran in 1834. In 1838, the line between Lancaster and Harrisburg was completed by the Harrisburg, Portsmouth, Mount Joy & Lancaster Railroad. This map from a later period shows the densely packed stations on the eastern end of the line and to a lesser degree the western end between Lancaster and Harrisburg. (Courtesy of Library of Congress.)

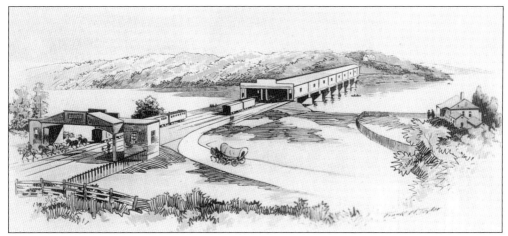

Opened in 1834 by the Commonwealth of Pennsylvania, the Philadelphia and Columbia Bridge over the Schuylkill River was the first railroad bridge constructed in the state. Railroad cars were towed over the bridge from near downtown Philadelphia by mules or horses, unhooked, and then hoisted up the inclined plane at Belmont using rope pulled by a stationary steam engine. Upon reaching the top of the plane, the cars proceeded west by steam locomotive, though animal power was also used on occasion. One of the first Main Line stations was located at the foot of the plane. (Courtesy of Library Company of Philadelphia).

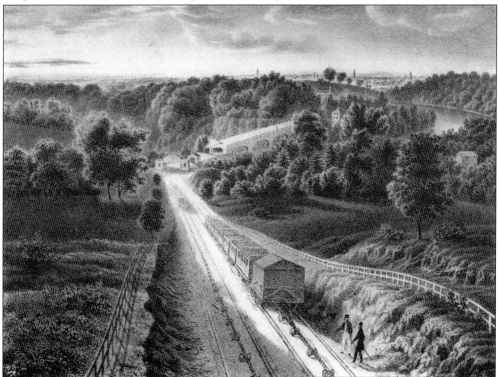

This image from an 1840 print shows railcars being lowered on the P&C Railroad's inclined plane at Belmont. After the cars were lowered, they continued across the P&C Bridge (seen in the distance) to their final destination at the railroad's terminal at Broad and Vine Streets in Philadelphia.

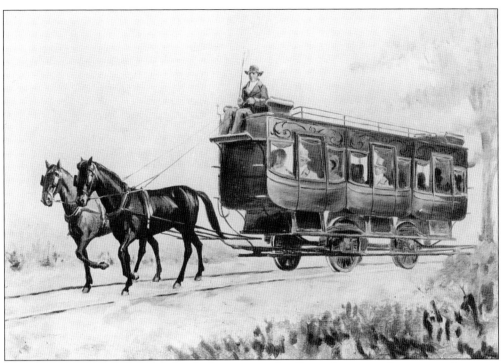

Cars on the P&C were towed at first by horses or mules. Even when steam locomotives began to be used regularly on the P&C, animal power was still used on occasion. Up until the opening of Broad Street Station in 1881, all streetcars running in Center City Philadelphia were towed by non-locomotive power. (Courtesy of Hagley Museum and Library.)

A Train for the Accommodation of Way Passengers will leave

COLUMBIA for PHILADELPHIA

Every Morning at **11** o'clock, and a like Train will *Leave Philadelphia* each Morning at the same hour, stopping at the following named points:

EASTERN TRAIN.

	H. M.			H. M.
Leave Basin at	1 P	Arrive at Coatesville	3	
Arrive at Mountville	11 50	" Gallagherville	3 20	
" Hempfield	12 15	" Downingtown	3 40	
" Lancaster (dine)	12 30	" Oakland	4	
" Bird-in-Hand	1 30	" Steamboat	4 15	
" Leaman's	1 50	" Paoli	4 45	
" Kinzer's	2	" Eagle	5	
" Gap	2 10	" Brookeville	5 20	
" Pennington's	2 30	" Whitehall	5 40	
" Parkesburg	2 45	" Philadelphia	6 30	

WESTERN TRAIN.

	H. M.			H. M.
Leave Philadelphia at	11	Arrive at Parkesburg	3 15	
Arrive at Whitehall at	12 20	" Pennington's	3 35	
" Brookeville	12 40	" Gap	4 10	
" Eagle	1	" Kinzer's	4 25	
" Paoli (to dine)	1 20	" Leaman's	4 35	
" Steamboat	1 50	" Bird-in-Hand	5 10	
" Oakland	2 10	" Lancaster	5 40	
" Downingtown	2 25	" Hempfield	6	
" Gallagherville	2 35	" Mountville	6 20	
" Coatesville	3	" Columbia	7	

A. MEHAFFEY,

Sup't Col. & Phila. R. R.

This is a very early train schedule between Columbia and Philadelphia from 1837. The westbound train left Philadelphia daily at 11:00 a.m. and made 18 stops (including a dinner stop at Paoli) before reaching the canal basin at Columbia on the Susquehanna River eight hours later. The eastbound train also left at 11:00 a.m. but had a schedule one half hour shorter. The trains passed each other in Coatesville, where both were scheduled to arrive at 3:00 p.m.

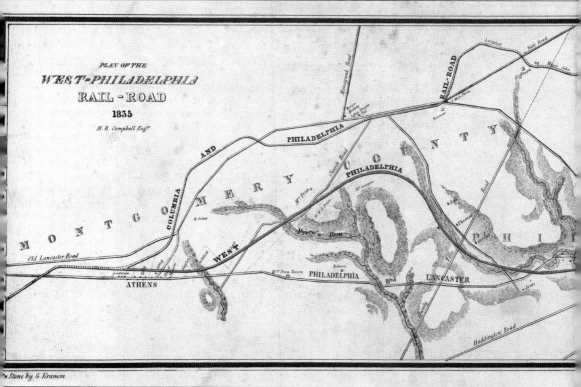

Soon after the Philadelphia and Columbia opened for traffic, a bypass was sought to avoid the Belmont Plane (seen as a straight section of track at top center). Not only was travel up and down the plane slow and dangerous, but the plane was also expensive to operate. In 1835, the West Philadelphia Railroad was incorporated in order to create a relatively straighter and higher capacity route from Athensville (present-day Ardmore) to the Market Street Bridge over the Schuylkill River and to avoid, as one newspaper reporter wrote, the "horrors and evils" of the Belmont Plane. The West Philadelphia Railroad failed to complete the line to the Schuylkill,

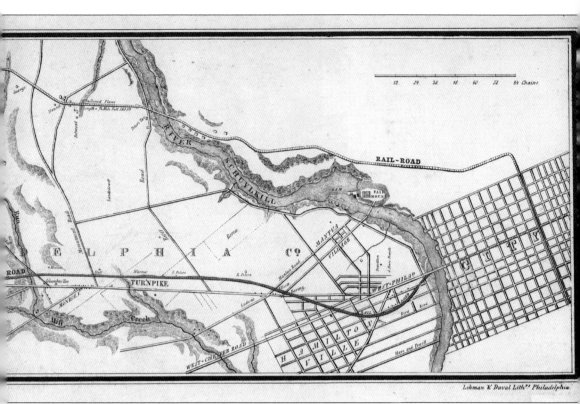

but in 1850, the state stepped in and finished the remaining section. As seen on the map, the railroad generally followed Lancaster Pike in West Philadelphia, but the final alignment (built by the state) ended up diverging from Lancaster Pike at Hestonville (Fifty-Second Street) to the Schuylkill River, then followed the river to the Thirtieth Street area. Passengers then took the horse-drawn railcars of the City Railroad over the Market Street Bridge into Center City. (Courtesy of Library of Congress.)

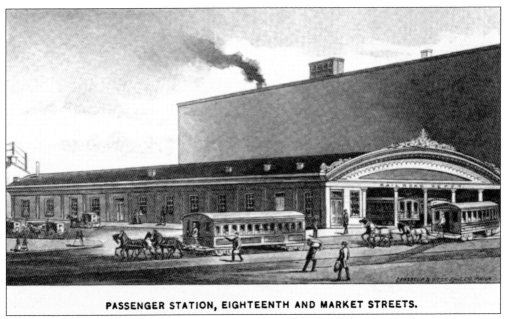

PASSENGER STATION, EIGHTEENTH AND MARKET STREETS.

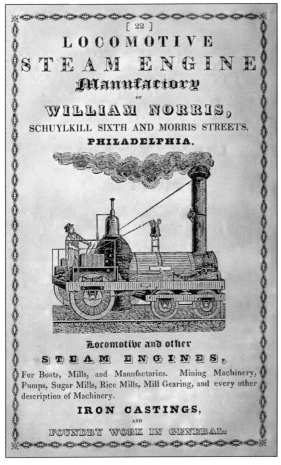

[22]

LOCOMOTIVE STEAM ENGINE Manufactory

OF

WILLIAM NORRIS,

SCHUYLKILL SIXTH AND MORRIS STREETS,

PHILADELPHIA.

Locomotive and other

STEAM ENGINES,

For Boats, Mills, and Manufactories. Mining Machinery, Pumps, Sugar Mills, Rice Mills, Mill Gearing, and every other description of Machinery.

IRON CASTINGS,

AND

FOUNDRY WORK IN GENERAL.

The P&C Railroad built its first terminal at Broad and Vine Streets in 1831. After the Belmont Plane was abandoned, the P&C brought its trains to the west side of the Schuylkill River at the Market Street Bridge via the West Philadelphia Railroad. The depot seen here at Eighteenth and Market Streets was used after the realignment. Train cars were unhooked from the locomotives and brought over the bridge to Center City by horsepower.

An old advertisement is seen here for the Norris Locomotive Works, which built over 1,000 steam engines between 1832 and 1866 at its factory in Philadelphia. Among these was the *Black Hawk*, which was the first steam-powered locomotive to run the entire length of the P&C Railroad. On April 15, 1834, the *Black Hawk* took 55 minutes to run from Columbia to Lancaster. The following day, it took eight and a half hours to reach Philadelphia.

These stone blocks once held the rails for the original P&C Railroad. A piece of iron called a chair was bolted to a flattened section of block and the iron rail was attached to the chair. These blocks were photographed at the old Whitehall Station in Bryn Mawr (left, now the Bryn Mawr Hospital Thrift Shop) and the former P&C station in Christiana, Lancaster County (right). They were recovered near each respective location.

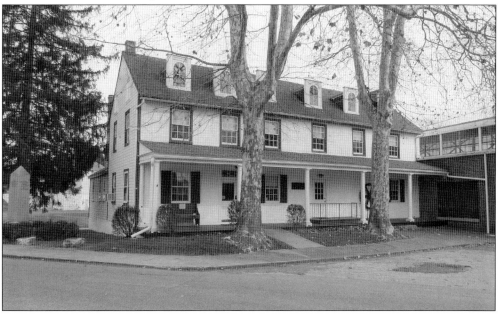

This building in Christiana, Lancaster County, served a number of purposes over its history including as a P&C Railroad station. Its placement at an angle to the road indicates the original alignment of the P&C near the village. A stone culvert of the original railroad also still stands a short distance away. The building now houses the Christiana Underground Railroad Center and offices for a local machine shop.

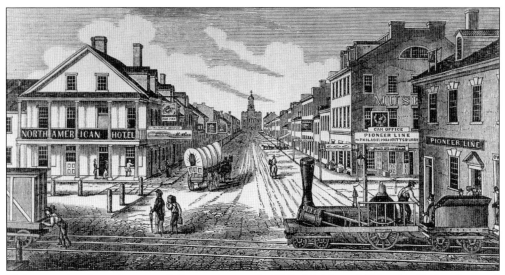

This engraving shows Lancaster's first station on the Philadelphia and Columbia Railroad around 1841. The view is looking south, with the courthouse visible at the far end of North Queen Street. The Pioneer Line on the right sold tickets for the P&C. The artist should have drawn an additional rail—the car on the left and locomotive on the right are sharing the middle rail.

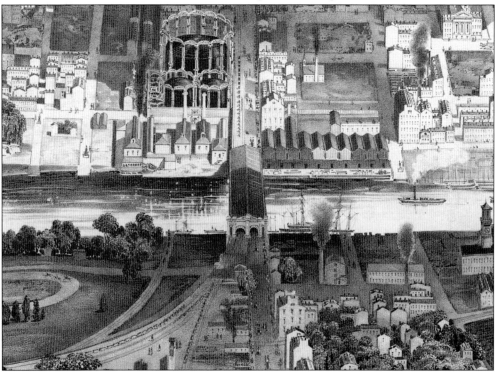

Philadelphia's Market Street Bridge across the Schuylkill River (seen in this bird's-eye view looking east) was constructed in 1850, replacing one that burned the same year. When reconstructed, the bridge was widened to include a rail line. The West Philadelphia Railroad ended at the west end of the bridge, about where Thirtieth Street Station is currently located, and the railcars were towed by horses into Center City. (Courtesy of Library of Congress.)

Two

PHILADELPHIA CENTER CITY AREA

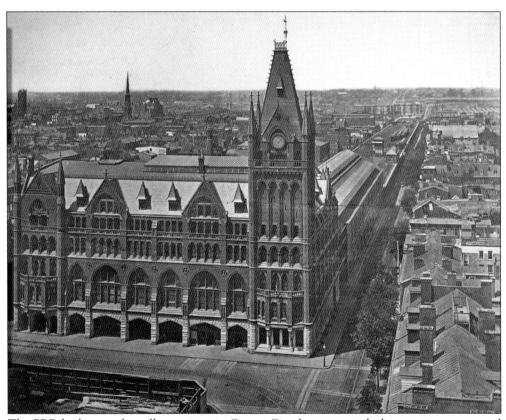

The PRR built several smaller stations in Center City, but none with direct train access until 1881. Prior to this time, patrons either had their cars towed into and out of Center City by non-locomotive power from the Thirtieth Street area or used other modes. This photograph shows Broad Street Station soon after it was completed in 1881. It was significantly expanded a decade later. (Courtesy of PhillyHistory.org, a project of the Philadelphia Department of Records.)

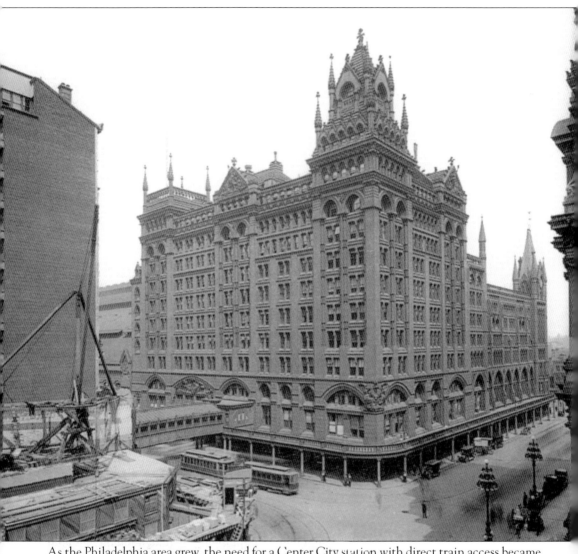

As the Philadelphia area grew, the need for a Center City station with direct train access became apparent. The PRR developed a plan in the late 1870s to construct a large terminal at Broad and Market Streets across from Philadelphia City Hall in the heart of Center City. Access to the station would be on elevated tracks so as not to impede vehicular traffic. The massive viaduct on which the tracks were constructed became unofficially known as the "Chinese Wall." The station opened in 1881 but was significantly expanded a decade later due to increasing passenger volumes. This photograph shows the station around 1920. The original 1881 section including the clock tower is on the right. (Courtesy of Library of Congress.)

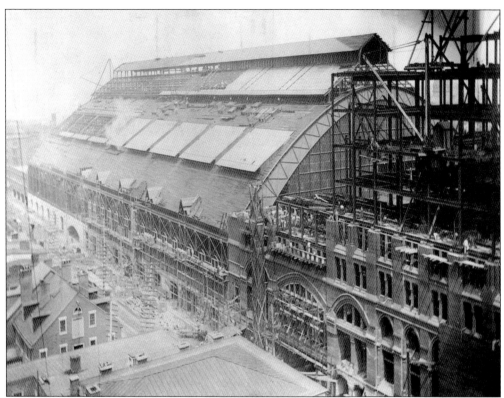

After it was completed in the early 1890s, this massive train shed, which covered 16 tracks at Broad Street Station, was the largest single-span train shed in the world at the time. The station's office tower, which would house the PRR's headquarters, is being constructed on the right. (Courtesy of Library of Congress.)

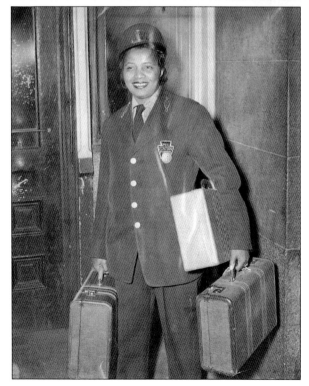

PRR employee Helen J. Atwood of Philadelphia carries luggage as a redcap at Broad Street Station in October 1943. Railroads were among many industries where women filled the jobs traditionally held by men as a result of the manpower shortage during World War II. (Courtesy of Temple University Libraries.)

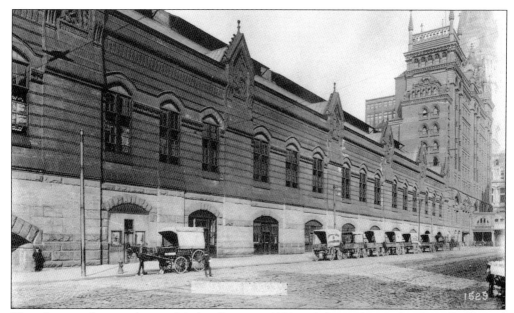

This photograph was taken on Market Street in 1903 and shows the south side wall of Broad Street Station's train shed. The tower of city hall can be seen behind (east of) the station. From the station west to the Schuylkill River, the tracks were carried on a large stone viaduct dubbed the "Chinese Wall." This structure was the bane of Philadelphia for decades as it served as an impediment to the natural growth of this area of the city. (Courtesy of Library of Congress.)

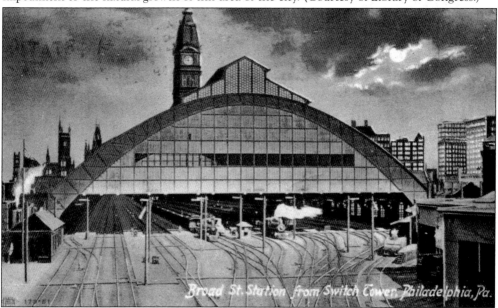

This postcard shows the approach to Broad Street Station from West Philadelphia. In 1923, the train shed was destroyed by fire. By the late 1920s, work commenced on replacing Broad Street as the city's main station. Suburban Station, which opened nearby in 1930, handled Center City commuter operations, and Thirtieth Street Station in West Philadelphia eventually handled long-distance through trains. The last train departed Broad Street in 1952 and the station was demolished the following year.

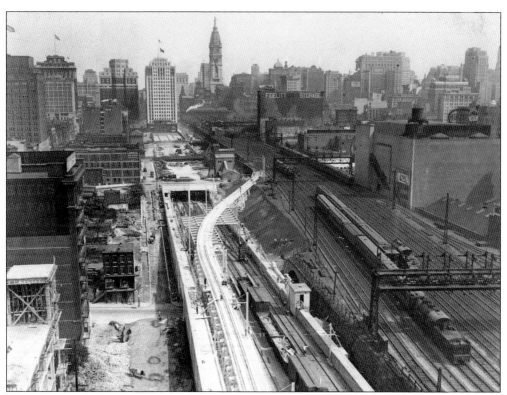

This photograph taken in the late 1920s shows tracks under construction to Suburban Station next to the tracks on the "Chinese Wall" going to Broad Street Station. Notice the temporary track to Broad Street built on cribbing over the new Suburban tracks. On the Broad Street tracks, a number of different train movements are going on in order to move trains into and out of the stub-end terminal, including two passenger trains being assisted by a steam locomotive (left) and a B1 electric switcher locomotive (right). (Courtesy of Temple University Libraries.)

The PRR's Suburban Station opened in 1930 and was a stub-end terminal in Center City for commuter operations. Starting that year, commuter trains arriving in Philadelphia stopped first at the newly opened suburban wing of Thirtieth Street Station, crossed the Schuylkill River on a new stone-arch bridge, then descended underground to Suburban Station. In 1984, a connection opened that linked Suburban Station with the former Reading Railroad's commuter lines via a 1.7-mile tunnel. A new station called Market East (renamed Jefferson Station in 2014) was constructed to replace the former Reading Terminal, which was also a stub-end terminal in Center City.

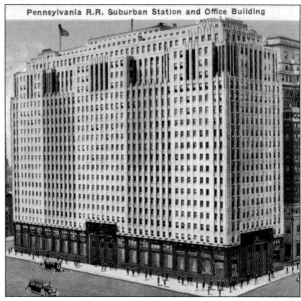

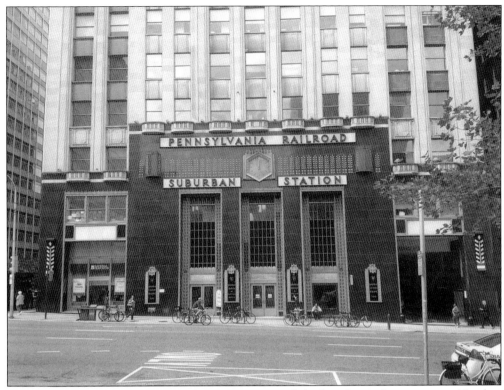

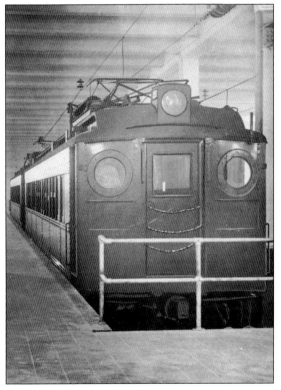

Suburban Station's entrance on North Sixteenth Street still maintains the PRR's name and logo. This striking Art Deco building housed the railroad's headquarters from 1930 to 1957. Amtrak operated its Silverliner and then Keystone trains from Harrisburg to Suburban Station until 1984. SEPTA now operates all commuter trains through the station. The station is mile marker 0—all station mileages on the Main Line start from Suburban Station.

Two PRR MP54 cars are stopped at the end of one of the tracks at Suburban Station on September 29, 1930, the day after the station opened. The MP54s could be operated from either end of the car, which eliminated a time-consuming locomotive switching operation. This is milepost 0; all distances for stations, switching towers, bridges, and other infrastructure on the Main Line are from this point in Suburban Station. (Courtesy of Temple University Libraries.)

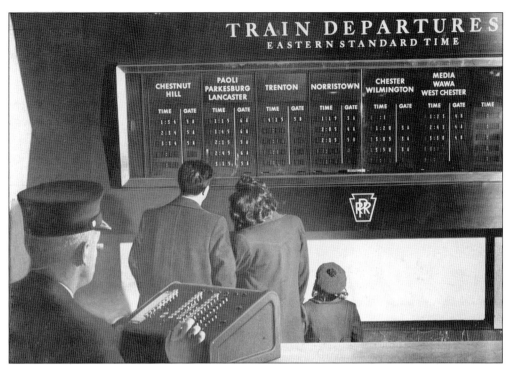

A railroad employee demonstrates a new electronically operated train departure board in Suburban Station in 1952. With this device, operators could quickly update the time and track locations of inbound and outbound trains at the busy station in Center City. Most large stations today have train information on LCD displays. (Courtesy of Temple University Libraries.)

This photograph, titled "Where to Please?," shows PRR ticket seller Alice Kohler at work in Suburban Station in 1942. Each of the tickets in front of her is for a specific station and they are arranged in order geographically for the various PRR lines. The ticket at top left is for New York City's Penn Station and those at the bottom are for destinations in western Pennsylvania. (Courtesy of Temple University Libraries.)

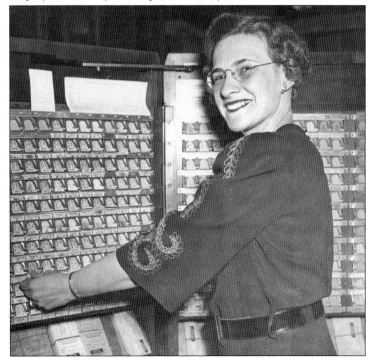

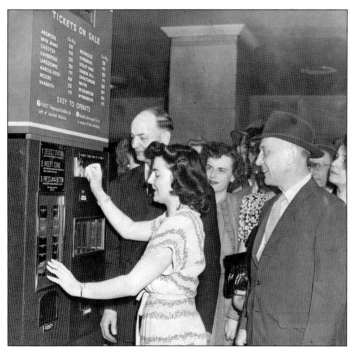

Passengers watch as a PRR employee demonstrates how to use a new ticket vending machine at Suburban Station in 1946. Only 16 locations could be handled on this particular machine, including the more popular stations to and from Center City, seven of which were on the Main Line. One-way fares posted on the machine include 17¢ to Overbrook or Narberth, 22¢ to Ardmore or Bryn Mawr, and 33¢ to Wayne. (Courtesy of Temple University Libraries.)

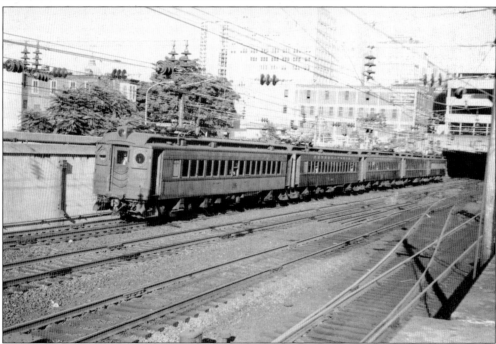

Though the new connection between West Philadelphia and Suburban Station opened in 1930, the parallel elevated line to Broad Street Station (the "Chinese Wall") was still used until Broad Street closed in the early 1950s. Vehicular and pedestrian traffic flow, and the overall look of this section of Center City, considerably improved after its removal. This image from 1968 shows a PRR train emerging from the tunnel at Twentieth Street after leaving Suburban Station. In another minute, it will make its first stop at the upper level of Thirtieth Street Station.

Three

PHILADELPHIA THIRTIETH STREET AREA

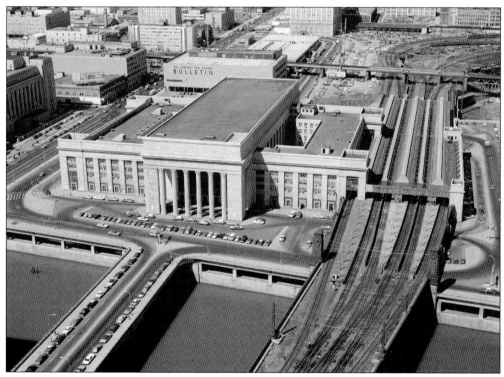

The west bank of the Schuylkill River with Thirtieth Street Station is seen in this view from April 1977. Philadelphia's geography played a major role in the planning and construction of the city's first rail lines. Steam powered locomotives were generally not allowed to operate in Center City until the 1880s. As a result, West Philadelphia was the city's primary location for passenger and freight terminals. (Courtesy of Library of Congress.)

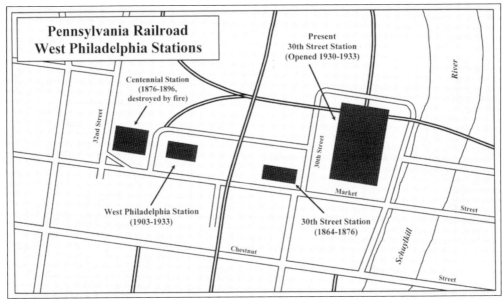

From the 1860s to the present, there have been four major stations on the west bank of the Schuylkill River. The first one, like the present, was called Thirtieth Street Station and was used between 1864 and 1876, when it was replaced by Centennial Station. This station, as its name suggests, was built for the 1876 Centennial Exhibition. It was destroyed by fire in 1896 and replaced by West Philadelphia Station in 1903. West Philadelphia was abandoned in 1933 and torn down. The current Thirtieth Street Station opened in stages between 1930 and 1933.

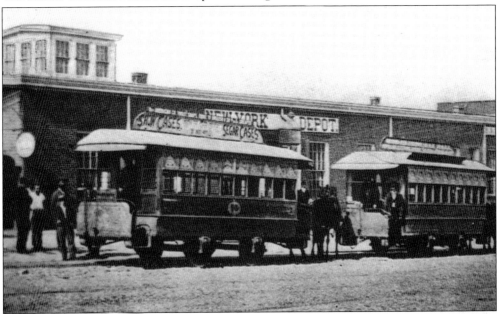

Built in 1864, this was the first of four stations west of the Schuylkill River in the Thirtieth and Market Streets area of Philadelphia. A city ordinance banned steam locomotives east of the Schuylkill River; as a result, passengers traveled on horse-drawn cars to and from the PRR's downtown stations and Thirtieth Street. This station was abandoned in 1876 after a new station was constructed for the Centennial Exhibition.

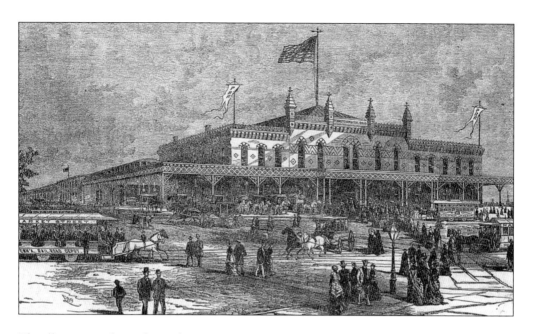

The illustration above shows the opening of Centennial Station in Philadelphia in 1876. The station was constructed at Thirty-Second and Market Streets and replaced a much smaller station two blocks east, which was built only 12 years prior. The new station was built specifically for the 1876 Centennial Exhibition and served as a gateway to Philadelphia for thousands of visitors that year. Special trains were run from here to a temporary station at the exhibition's entrance in Fairmount Park a short distance away. The photograph below was probably taken at some point in the 1880s when the station saw less use after Broad Street Station opened in 1881. Centennial Station was destroyed by fire in 1896. Notice the large train shed in the rear of the station. Through trains operated on tracks in the trench seen on the right.

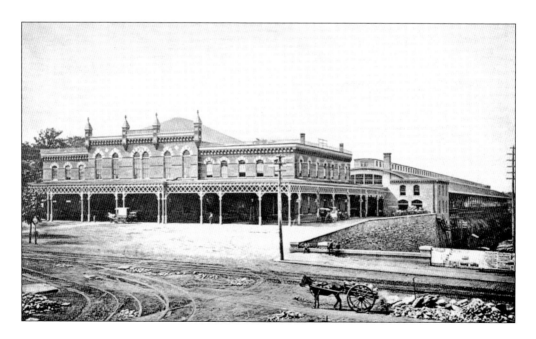

This is a rare c. 1890 photograph of West Philadelphia probably taken from the rear of a train headed to Broad Street Station just after it crossed Thirtieth Street. The photographer would have been directly over what is now the main concourse of Thirtieth Street Station. In the left background is the 1876 Centennial Station with its massive train shed extending to the right. The large structure on the left is a grain elevator and stockyards are on the right.

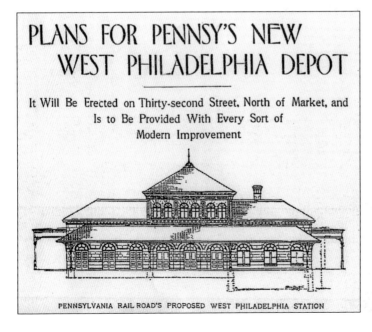

PLANS FOR PENNSY'S NEW WEST PHILADELPHIA DEPOT

It Will Be Erected on Thirty-second Street, North of Market, and Is to Be Provided With Every Sort of Modern Improvement

PENNSYLVANIA RAIL ROAD'S PROPOSED WEST PHILADELPHIA STATION

After Centennial Station was destroyed by fire in 1896, some rail traffic was shifted to nearby Powelton Avenue Station, but the small station was not adequate to handle the increased number of passengers. Broad Street was the main Philadelphia station, but a station was still necessary in West Philadelphia to handle the large number of through trains. These plans for West Philadelphia Station appeared in the *Philadelphia Inquirer* in 1901. (Courtesy of *Philadelphia Inquirer*.)

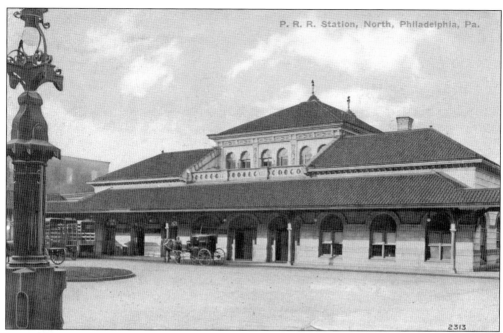

These postcard views show the newly constructed (1903) PRR station on Market Street between Thirty-First and Thirty-Second Streets. This station in West Philadelphia (not North, as titled in the postcard above) replaced the 1876 Centennial Station a block to the west, which was destroyed by fire in 1896. This station served trains that ran to and from Broad Street from platforms behind the station, which are visible in the image below, as well as New York–Washington through trains that were boarded on platforms below street level. The building on the right in the image below is a cab stand. The station was torn down after the current Thirtieth Street Station went into service in the early 1930s.

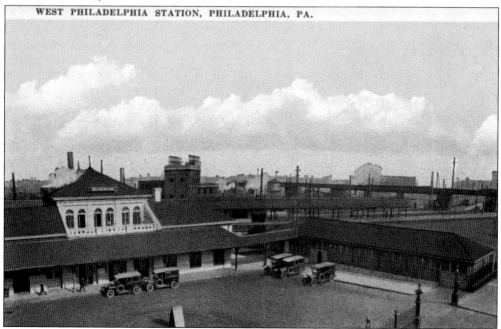

WEST PHILADELPHIA STATION, PHILADELPHIA, PA.

29

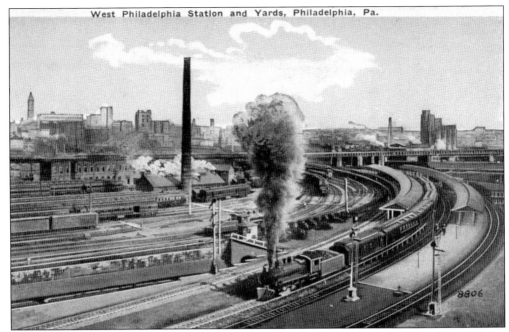

West Philadelphia Station and Yards, Philadelphia, Pa.

This c. 1930 postcard view (probably taken from an elevated position at Thirty-Second and Arch Streets) shows the complex system of tracks in West Philadelphia before the construction of Thirtieth Street Station. The curved platforms and canopies served the West Philadelphia Station built in 1903. Visible just above the steam engine is the portal for the through tracks that were used for trains bypassing Broad Street Station.

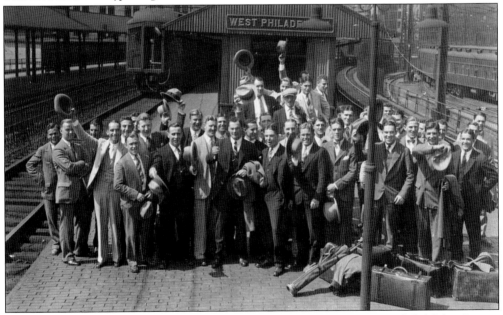

The University of Pennsylvania Quakers football team is about to depart West Philadelphia Station for a training camp at Sea Girt, New Jersey, in this photograph taken in late summer 1926. The Penn campus is also located in West Philadelphia. It appears that at least one player is hoping to get some golf in while at the Jersey shore. Some details of the station can be seen in the background.

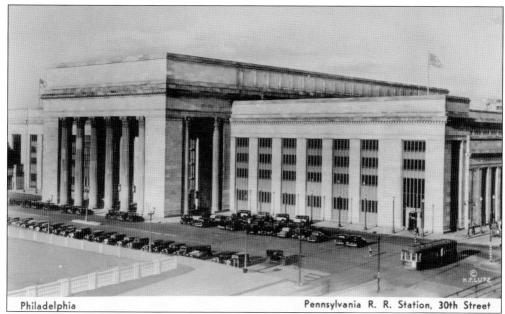

Philadelphia Pennsylvania R. R. Station, 30th Street

This view of Thirtieth Street Station's west portico was taken soon after the station opened in the mid-1930s. The sides facing Center City and West Philadelphia are 637 feet long, and the sides facing North and South Philadelphia are 327 feet long. The station is built with a steel frame faced with limestone. Each of the massive Corinthian columns is 71 feet high. Notice the streetcars running on Market Street to and from Center City.

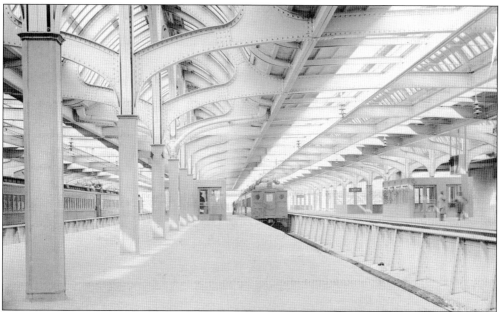

An electric PRR commuter train arrives at the recently opened sky-lit upper level of Thirtieth Street Station in October 1930. Construction of Thirtieth Street Station started in 1927, and it opened in stages between 1930 and 1933. The upper-level commuter wing opened on September 28, 1930, in conjunction with the opening of Suburban Station in Center City. (Courtesy of Temple University Libraries.)

31

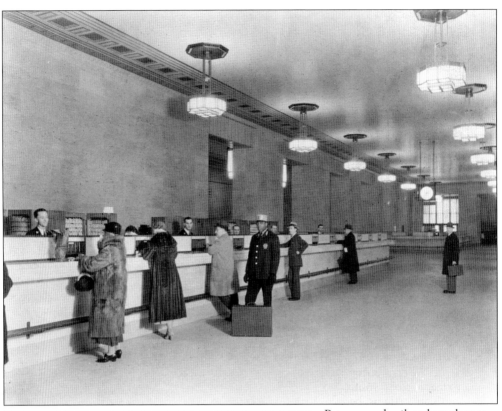

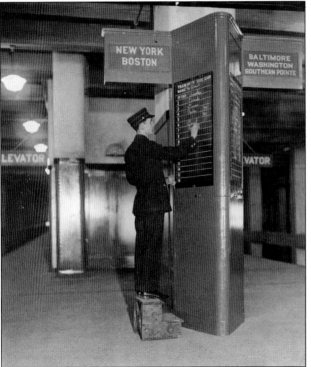

Patrons and railroad employees pause to get their picture taken at Philadelphia's Thirtieth Street Station in the 1930s. Shown here is the ticket counter off the main waiting room. Amtrak's customer service office is now in this location. The current ticket counter is at the far end of this area.

A PRR employee at Thirtieth Street Station writes the order of cars for the next train to arrive. This photograph was taken in 1933 on the lower level soon after the platforms opened for through trains. The "Smoker" was the first passenger car on this particular train. Today, the "Quiet Car," which prohibits loud talking and cell phone use, is the car many passengers look for when boarding. (Courtesy of Temple University Libraries.)

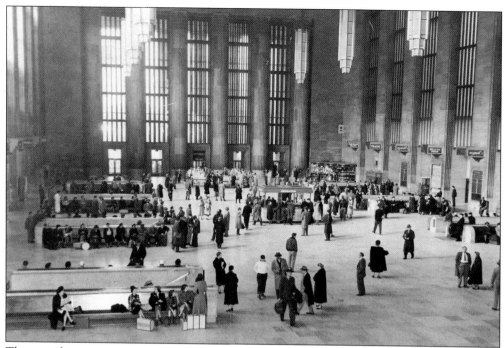

This view facing west towards Thirtieth Street shows the busy main concourse at Thirtieth Street Station in 1951. The concourse measures 135 feet by 290 feet, with walls of travertine and marble rising 95 feet to a beautifully painted plaster coffered ceiling. At both ends of the concourse are six Corinthian columns, behind which are double walls of glass windows. Between these walls are catwalks made of concrete and glass block that connect the office towers on either side of the concourse. The floor is made of Tennessee marble. Ten chandeliers, each 18 feet long, hang from the ceiling to help light the massive space. (Courtesy of Temple University Libraries.)

Passengers check the train information board at Thirtieth Street Station in February 1969. This board was eventually replaced by a split-flap display, also called a Solari board after the Italian manufacturer, and is one of the few such types still in use in the United States. The distinct flapping sound quickly draws the attention of passengers checking the status of their trains. Also notice that Thirtieth Street Station once had a bowling alley. (Courtesy of Temple University Libraries.)

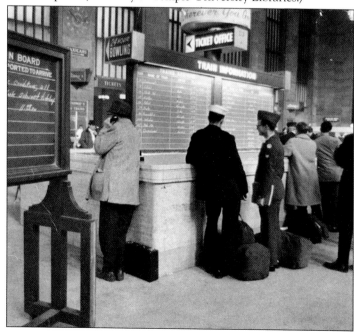

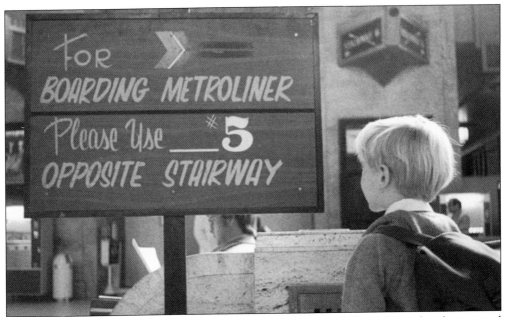

Metroliner service between New York and Washington began with Penn Central and continued with Amtrak. However, a Metroliner train ran for a short period on the Main Line in 1989. The weekday train originated in Downingtown at 6:00 a.m. and made several stops before arriving in Philadelphia shortly before 7:00 a.m. The train continued south and arrived in Washington, DC, at 8:35 a.m. It was convenient for those needing to arrive early in the nation's capital from the Philadelphia suburbs without making a connection. (Photograph by Richard L.W. Ruess.)

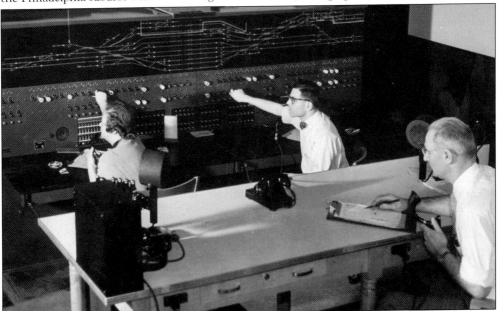

In the early 1950s, PRR employees at Thirtieth Street Station are operating an interlocking machine, which controls the signals and switches in the station area. The group of tracks in the center of the model board includes the 11 tracks that run underneath the station, 10 of which are alongside platforms for passenger boarding. (Courtesy of Temple University Libraries.)

Four

WEST PHILADELPHIA

Switch tender Charles
Burrs plies his trade
in the rail yards near
the location of the
old Powelton Avenue
Station around 1940.
Beginning with
Powelton Avenue
Station, there were
six stations along the
Main Line in West
Philadelphia before
Montgomery County
(Powelton Avenue,
Mantua, Fortieth
Street, Girard Avenue,
Fifty-Second Street/
Hestonville, and
Overbrook) that served
the city's population as it
moved westward, though
they were not all in
service at the same time.
Of these stations, only
Overbrook is still in use.

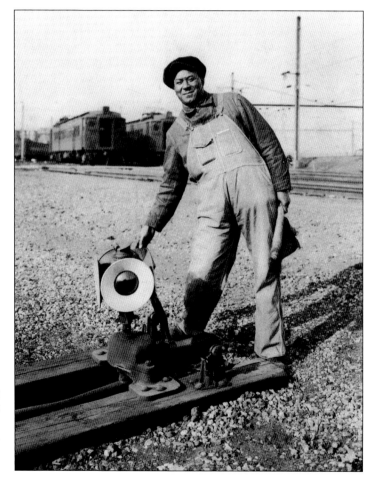

The photograph above shows the shelters and footbridge of the Powelton Avenue Station in West Philadelphia. The station building itself (not shown) was to the north (left) in the photograph. The station was located only a quarter mile past the main station at Thirty-Second and Market Streets, as seen in the map below, and was technically the first stop along the Main Line after departing the main Philadelphia stations. Local passengers and passengers on through trains needing to get to Center City would use Powelton Avenue Station for the short ride to Broad Street Station. The station was closed and demolished after West Philadelphia Station opened at Thirty-First and Market Streets in 1903. One of three engine houses can be seen on the right. The tracks veering off to the left accessed the Centennial Station.

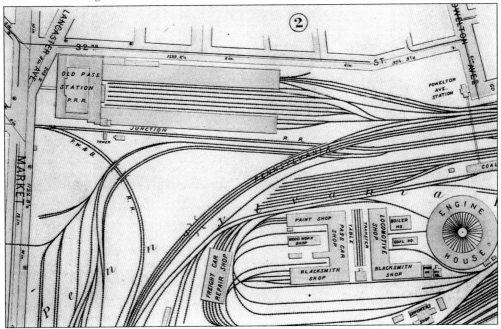

A station at Mantua (Thirty-Fifth Street) was in service for a short time in the 1800s. The next was Fortieth Street Station (above). It was abandoned in 1901, but due to pressure from the local community, was reopened in 1908. Low patronage, however, resulted in its permanent closure in 1915. A PRR general manager argued that keeping the station open was "an economic waste and disadvantage to the public to maintain a station of this character in a thickly populated city within so short a distance—2.8 miles—of the company's main terminal." After Fortieth Street Station was Girard Avenue Station (below). Competing trolley service and its proximity (only one half mile west) to Fortieth Street Station led to this station's closure in 1895.

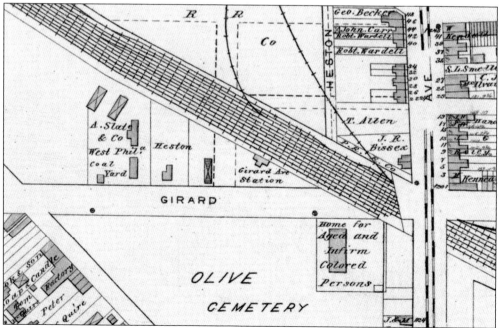

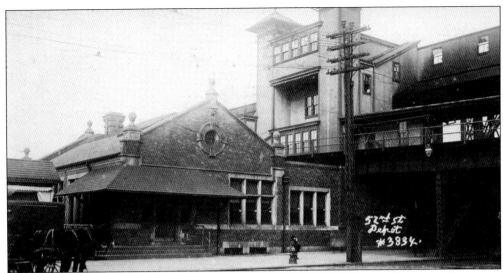

This is a rare image of the PRR's Fifty-Second Street Station. The building was at ground level with two tiers of tracks above the street. The first level was the Main Line and the second level was the PRR's Schuylkill Division. Platforms to both tracks were accessed via enclosed stairways. In June 1900, a trolley wire came into contact with an iron spout on the station roof, causing a fire that could have destroyed the building if not quickly put out by station agent George Good and others.

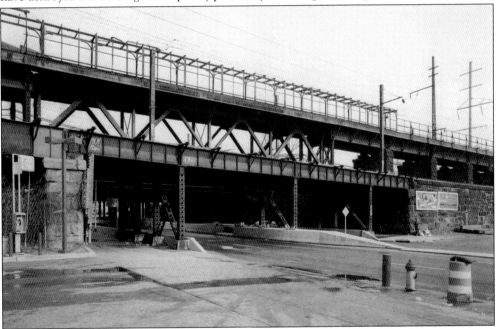

The Fifty-Second Street Station is long gone, but remnants of the platform and canopy are still visible on the former Schuylkill Division tracks in this c. 1990 photograph. As far back as the early 1900s, there was discussion of abandoning the station due to low ridership resulting from streetcar competition. Amtrak serviced the station from 1975 to 1980 (when it was abandoned) primarily for reverse commuters who went to morning jobs along the Main Line. SEPTA still runs on the tracks of the old Schuylkill branch as far as Cynwyd with a single-car train. (Courtesy of Library of Congress.)

Seen here from a different perspective (and, unfortunately, on a broken glass plate) is the Overbrook Station around 1910. The main station building can be seen on the far right and the outbound shelter, which also still stands today, is at right center. Freight platforms are on both sides of the tracks. The bridge crossing the tracks is on City Avenue, which is the boundary line between Philadelphia and Montgomery Counties. (Courtesy of Hagley Museum and Library.)

Advertisements like this one became common in the Philadelphia newspapers in the late 1800s. Initially, resorts and hotels on the Main Line sought to attract Philadelphia residents looking to escape the city, especially during the heat of the summer. But developers soon sought to lure these same residents to live permanently outside the city and use the railroad for daily commuting. Many executives of the Pennsylvania Railroad lived in Main Line communities.

BUILDING SITES.

On the Main Line of the Pennsylvania Railroad.

Building Sites One-Quarter Acre and Upwards.

OVERBROOK

Building Sites One-Quarter Acre and Upwards.

On the Main Line of the Pennsylvania Railroad.

12 Minutes' Ride From Broad Street Station.

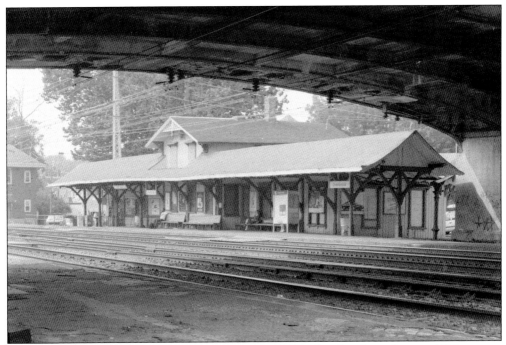

Passengers wait for an inbound SEPTA train to arrive at Overbrook in these c. 1990 images. Overbrook also has a large number of reverse commuters who use the outbound shelter seen below to travel to work and school in the Philadelphia suburbs. Also notice there is no fencing on the tracks due to the crossovers at Overbrook. The switches are controlled in the tower seen at far left above. The station's name originates from the brook (Mill Creek) that ran under the station. (Courtesy of Library of Congress.)

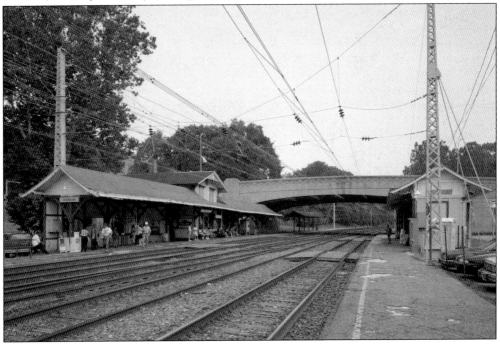

Five

MONTGOMERY COUNTY

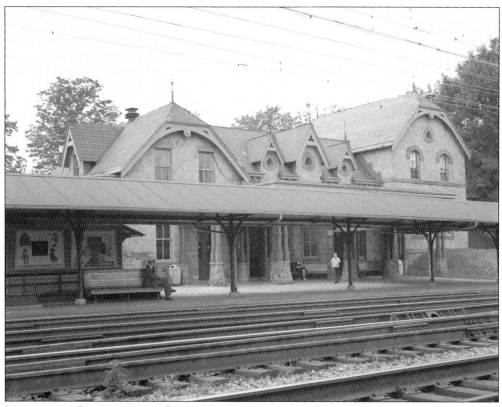

Montgomery County starts at the City Line Avenue bridge that crosses the tracks at Overbrook Station. Several of the most beautiful stations along the Main Line were in this county, including Ardmore and Bryn Mawr, the latter of which is seen here in the early 1960s before it was torn down. (Courtesy of Eugene DiOrio.)

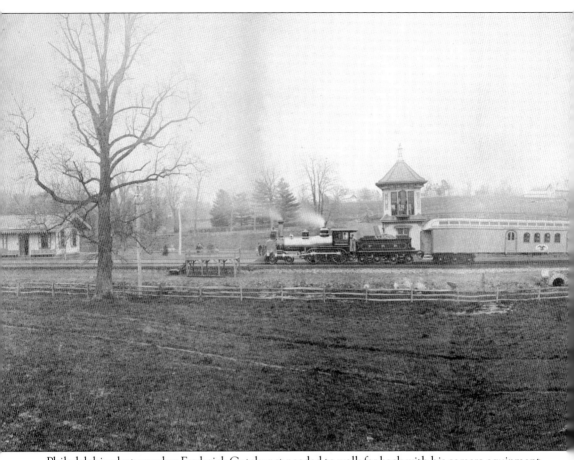

Philadelphia photographer Frederick Gutekunst needed to walk far back with his camera equipment to capture this panoramic image of a long train at Merion Station in 1875. Merion was the first stop on the Main Line west of the Philadelphia city limits. As far back as the 1860s, "desirable country residences" at Merion were listed in newspaper advertisements that touted the benefits of the proximity to the railroad and the short ride to Philadelphia. Gutekunst was called the dean of

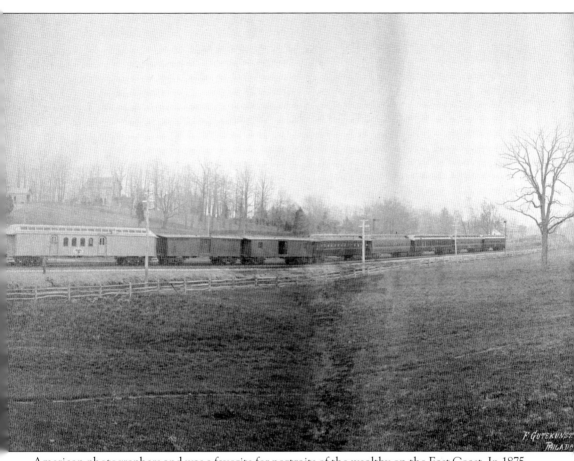

American photographers and was a favorite for portraits of the wealthy on the East Coast. In 1875, a commission given to Gutekunst by the PRR resulted in nearly 250 stereographs documenting stations, bridges, tunnels, and the natural beauty along the railroad's divisions. (Courtesy of Historical Society of Pennsylvania.)

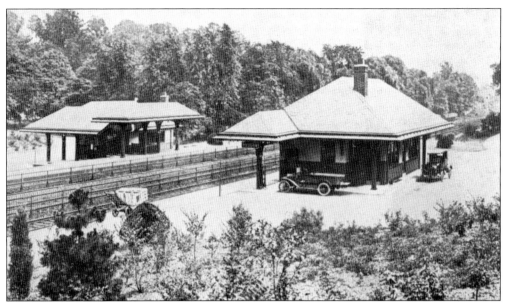

Merion Station is shown in these photographs at about the same time (probably the late 1920s). The station was built in 1917 by the PRR after "campaigning so ardently" by the Merion Civic Association. The station was located on the south side of the tracks, and the building on the north side (as seen above) is the Merion Station Post Office, which was built the same year "to permit homebound residents to call for their mail in the evening as soon as they leave their trains," according to the *Harrisburg Telegraph*. Both photographs show the standard station carts loaded with luggage awaiting the next train. (Above, courtesy of the Archives of the Lower Merion Historical Society; below, courtesy of Temple University Libraries.)

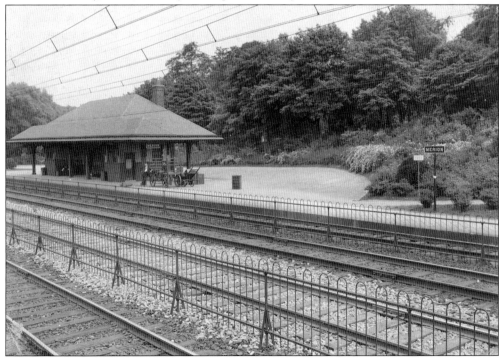

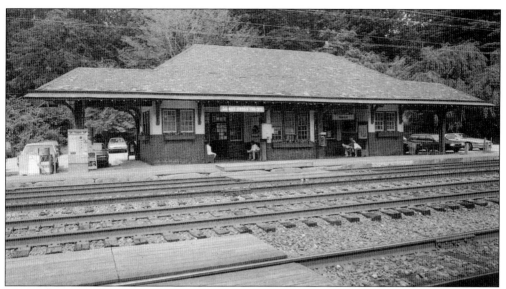

The well-maintained station building and beautified grounds (including filled flower boxes) of Merion Station are due in part to the assistance of the Merion Civic Association, which was established in 1913. This photograph shows passengers waiting for a SEPTA train at Merion in the early 1990s. (Courtesy of Library of Congress.)

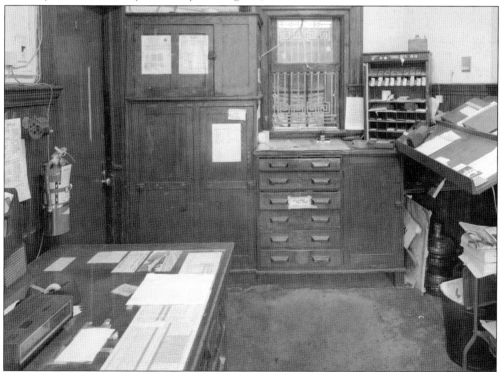

This is a look inside the ticket office at Merion Station. A clock radio and debit card reader are telltale signs of the more recent date of this photograph (probably from the early 1990s), but the furnishings and woodwork are most likely original from when the station was built in 1917. (Courtesy of Library of Congress.)

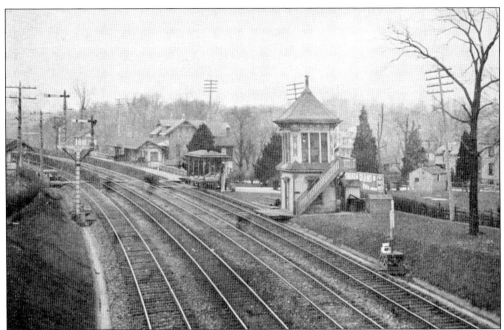

There is a lot to show in the above c. 1895 photograph of Narberth Station. This view faces west and was probably taken from the Narberth Avenue Bridge. Unlike most stations on this section of the Main Line, the larger station building is on the north (outbound) side of the tracks. Notice the ornate switching tower and the semaphore signals across the tracks, both of which are in the stop position. There is also a small covered platform to handle local freight. The inbound shelter is visible on the left. The photograph below of Narberth Station was taken at an earlier time, when it was known as Elm. It can be seen in the image above behind the canopy. (Below, courtesy of the Archives of the Lower Merion Historical Society.)

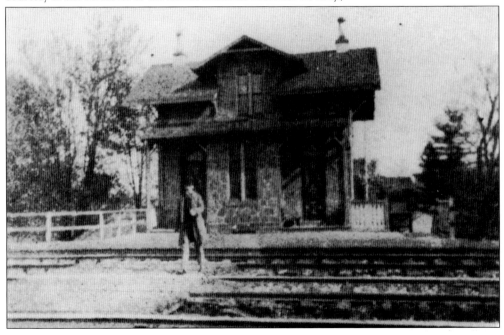

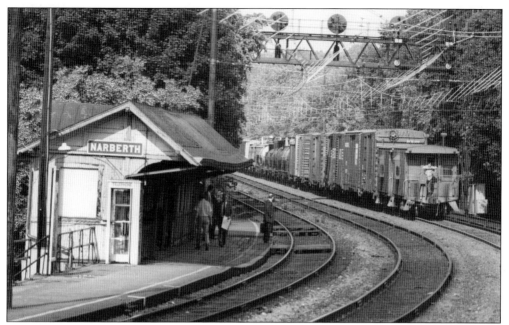

Narberth passengers waiting for their train to Philadelphia pause to watch a westbound Penn Central freight train pass on a warm morning in May 1974. The Main Line was also a busy freight line as well as passenger line. Nowadays, there is some daily freight activity in the Lancaster and Coatesville areas, but none east of Paoli. Remnants of numerous sidings and freight warehouses can still be seen along the tracks. (Photograph by Richard L.W. Ruess.)

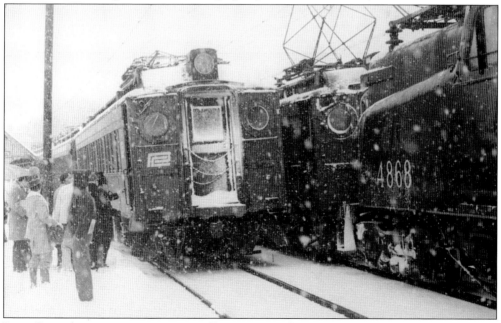

Penn Central commuter trains were still running on the Main Line during this snowstorm in the early 1970s. This MP54 set is picking up passengers at Narberth. Next to it, in a unique combination, is another set of MP54 cars being pulled by a GG1 locomotive. (Photograph by Richard L.W. Ruess.)

The station at Wynnewood dates to 1870 and is the only one remaining in Lower Merion Township designed by Wilson Brothers and Company architects. The Villanova and Haverford Stations in Delaware County are of a similar style. The area was named after Thomas Wynne, president of the first Pennsylvania Provincial Assembly that convened in Philadelphia in 1683 and who owned the property on which the station stands. An 1874 publication described Wynnewood: "There are many beautiful building-sites convenient to the [rail]road in this locality, and the tide of improvement must soon bring them into requisition." (Both, courtesy of Library of Congress.)

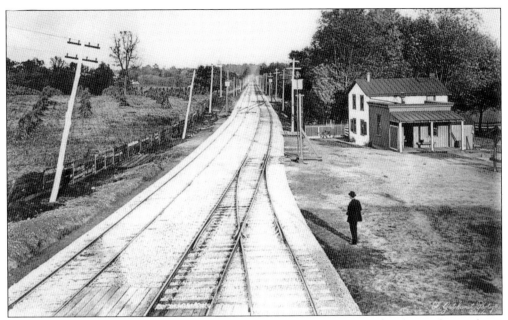

This photograph taken around 1875 by Philadelphia photographer Frederick Gutekunst shows Wynnewood Station (and attached home) built prior to the one currently in use. The man in the foreground is looking east toward Philadelphia. The ballast and track appear to be well maintained. Also notice the old style track signal, which was used for the short siding that branches off the Main Line on the right. (Courtesy of Library Company of Philadelphia.)

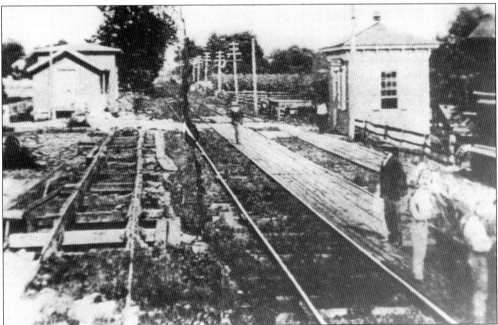

Prior to the grand station at Ardmore, this diminutive structure on the right served the location when the area was known as Athensville. The photograph was taken around 1860. A portion of a locomotive can be seen on the right and a small freight station and siding are on the left. (Courtesy of the Archives of the Lower Merion Historical Society.)

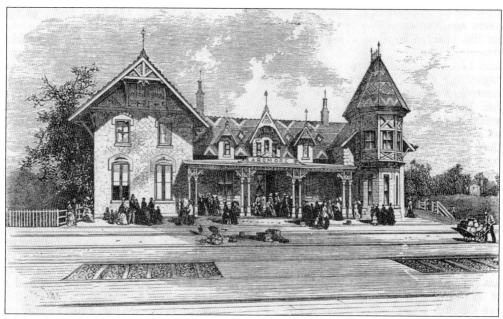

This is the Ardmore Station in the 1870s. The elaborate stone structure was designed by Wilson Brothers and Company architects, who designed a number of stations along the Main Line. In addition to a waiting area, ticket office, and baggage room, the station also had living quarters for the station agent and his family. A two-story signal tower was attached to the station and can be seen on the right.

PENNSYLVANIA RAILROAD CO.

MONTHLY TICKET RATES
Between Philadelphia and stations given below.
IN EFFECT MAY 1st, 1874.

*Mantua	$2 50	*Wayne	$6 90
*Hestonville	2 70	*Eagle	7 30
*Overbrook	3 25	Reeseville	7 75
Merion	3 45	*Paoli	8 25
*Elm	3 60	Green Tree	8 40
*Wynnewood	3 80	*Malvern	8 50
*Ardmore	4 60	Frazer	9 25
*Haverford College	4 85	*Glen Loch	9 75
*Bryn Mawr	5 10	Whiteland	10 25
*Rosemont	5 40	*Oakland	10 75
*Villa Nova	5 80	Woodbine	11 50
Upton	6 00	*Downingtown	12 00
*Radnor	6 50		

Similar to passes sold today on SEPTA and Amtrak for travel on the Main Line, commuter passes were sold by the PRR as far back as the 1870s, as this chart shows. Monthly passes had numbers 1 to 54 printed on the margins and conductors canceled a number each time a trip was made.

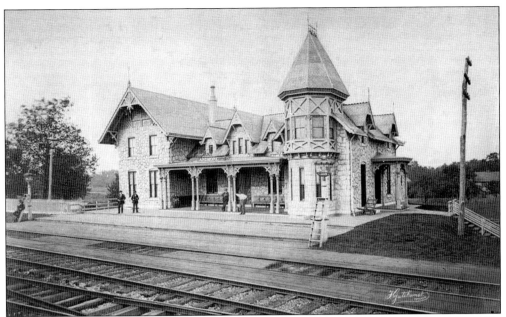

Ardmore was one of the most beautiful stations ever constructed on the Main Line, as this 1870s photograph attests. Many of the Main Line stops not only had beautiful and well-maintained station buildings, but also attractive landscaped grounds. Also, notice the gaslights that the agent lit each night using the ladders leaning against the posts. At far left, a man rests against one while waiting for a train. The station was destroyed by fire in the 1950s. (Courtesy of Library Company of Philadelphia.)

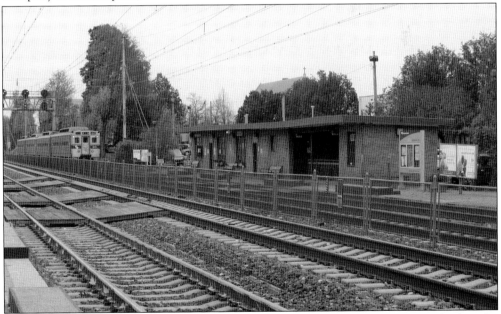

Ardmore's current station is a single-story, nondescript (though functional) structure built in the 1950s. It is served by most SEPTA trains. It is also the only Amtrak stop on the Main Line east of Paoli. Amtrak's Heartland Flyer stops at Ardmore, Oklahoma, which took its name from the Main Line community in Pennsylvania.

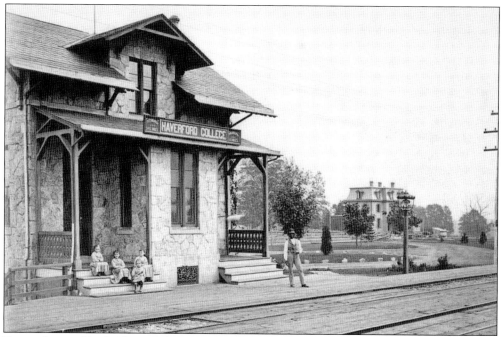

Four girls, possibly children of the station agent, sit on the steps of Haverford College Station in the above photograph taken around 1875 by Philadelphia photographer Frederick Gutekunst. The man on the right may work at the station. The entrance on the left went to the agent's residence. The entrance on the right went to the ticket office. The modern-day photograph below, taken from the same angle, shows the changes to the station, though these modifications were actually done sometime in the 1880s. Eventually, the name of the station was shortened to Haverford Station. The current SEPTA ticket office is located on the south side of the tracks in another station building that was built at a later time. (Above, courtesy of Library Company of Philadelphia.)

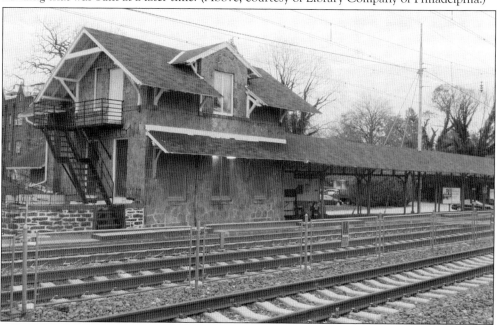

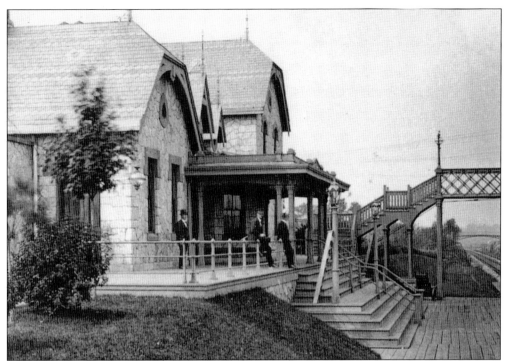

Several men pose on the porch of Bryn Mawr Station around 1875. Called an "embryo town" by one newspaper, Bryn Mawr was developed by the PRR in the early 1870s to be "one of the most desirable of the numerous out-of-town but near-the-city places of residence now to be found around Philadelphia in every direction." (Courtesy of Library Company of Philadelphia.)

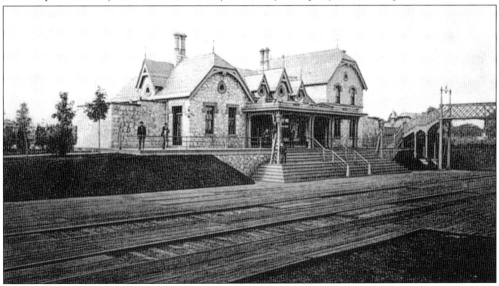

Certainly one of the most beautiful stations on the Main Line was Bryn Mawr's, seen in this c. 1875 photograph. Like many stations along the Main Line, the PRR complemented its architecturally striking stations with beautiful landscaping and well-manicured lawns. Though probably more functional for the loading of passengers and baggage, even the tracks surrounded by wooded decking have the appearance of a boardwalk. (Courtesy of Library of Congress.)

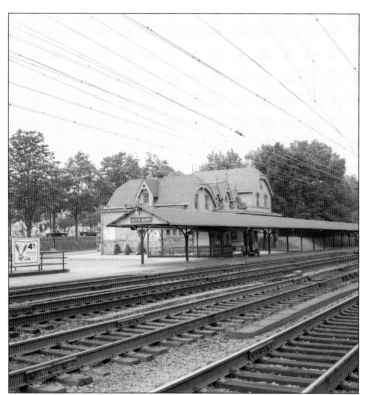

These Bryn Mawr images show the same view, but two different stations. The photograph at left was taken in August 1961 before the station was torn down. The photograph below is how the station looks today. The old canopy remains, but the former station was replaced by a smaller brick structure. A freight station built in the 1870s just to the east of the station still stands and is now a restaurant. In a layout like that of the Overbrook Station, there is no safety fence between the tracks at Bryn Mawr due to interlocking. (Left, courtesy of Eugene DiOrio.)

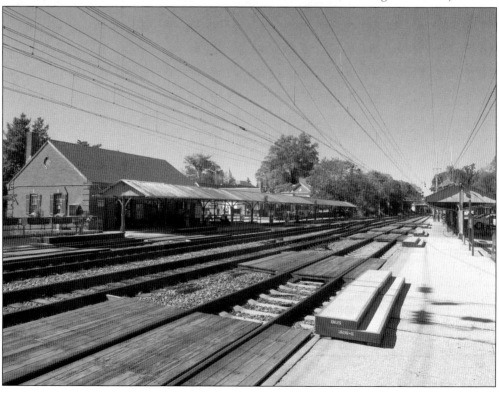

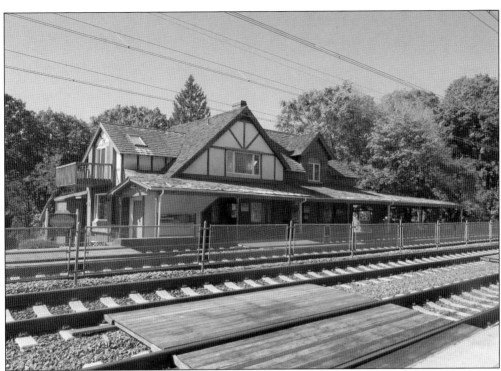

The station building at Rosemont is seen in this recent photograph. Similar to other stations along the "social" Main Line, Rosemont is an unincorporated community. It lies in both Lower Merion and Radnor Townships. This is the second station location for Rosemont along the Main Line. The former location was a short distance away but was moved in 1870 when the railroad was realigned between Rosemont and Ardmore (formerly Athensville).

Perhaps the shortest-lived station on the Main Line was County Line Station between Rosemont and Villanova. It was located on the Montgomery County side of the line on County Line Road. It is labeled on this 1881 map and is also briefly mentioned in the *Philadelphia Inquirer* as a stop near the Church of the Good Shepherd. No other information has been found on when service started or ended.

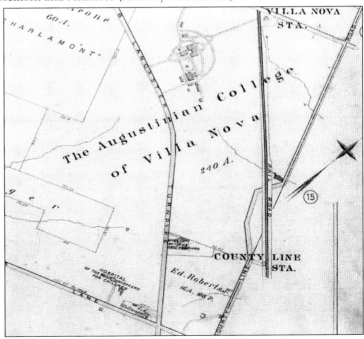

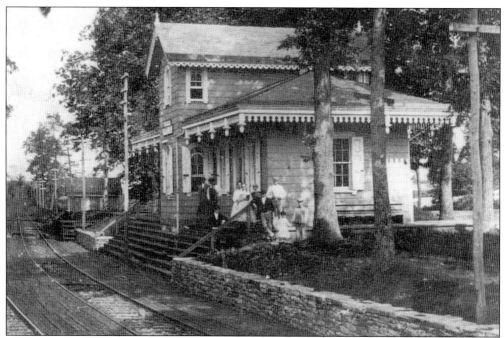

The very early view above, probably from the 1860s, shows Whitehall Station in Lower Merion Township before the realignment of the tracks to the north and the establishment of the community of Bryn Mawr. This beautifully maintained station set among mature shade trees was probably a gathering place for the local populace. Also notice the telegraph poles along the tracks and the small platform for handling local freight deliveries. Below, the station building still stands, as this modern view taken in the same location attests. Today, it houses the Bryn Mawr Hospital Thrift Shop. The slight curvature of Glenbrook Avenue in front of the building follows the old railroad alignment. (Above, courtesy of the Archives of the Lower Merion Historical Society.)

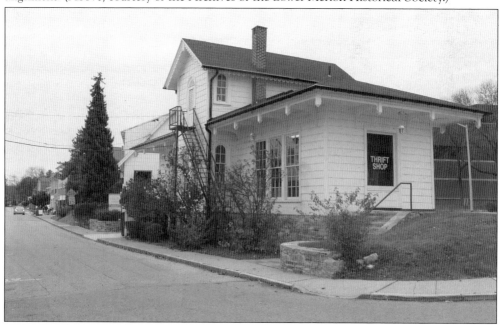

Six

DELAWARE COUNTY

Less than four track miles of the Main Line cut through a small section of northern Delaware County. The four stations in this section are all in Radnor Township—Villanova, Radnor, St. Davids, and Wayne. There was a fifth station at one point called Upton but it was abolished in 1899. This image is of the back side of the Radnor Station built in 1879 and shows the former agent's two-story residence.

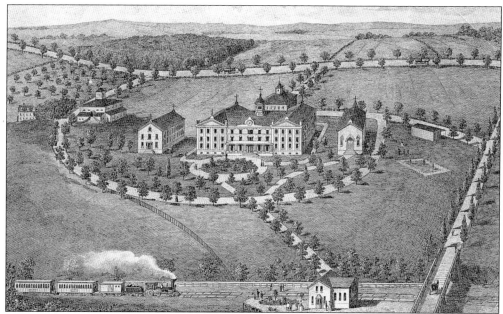

The importance of the railroad to Villa Nova College (as it was called at the time) is evident in this 1879 lithograph. The beautifully landscaped campus included a tree-lined path that ran from the main college buildings north to the railroad station. Many of the students in the earlier years of the school would have used the train to attend classes at the college. (Courtesy of Villanova University Archives.)

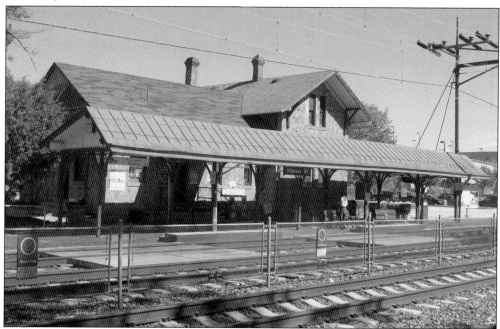

Villanova students wait for a westbound SEPTA train in this image taken on a warm day in early fall 2015. Conveniently located near the middle of the university's campus, the Villanova Station is well used by commuting students as well as faculty and staff. The station was built in 1890 and is in a style similar to those in Haverford and Wynnewood.

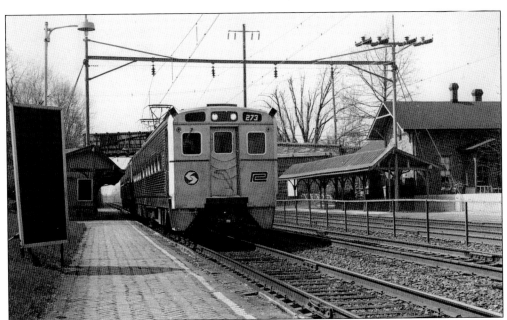

An eastbound commuter train with both SEPTA and Penn Central logos pulls into Villanova Station on a quiet Saturday in April 1976. Starting in the early 1970s, Penn Central ran commuter operations under contract for SEPTA. In 1976, Conrail took over the railroad-related assets of the bankrupt Penn Central—including commuter train operations, which continued under contract with SEPTA. In 1983, SEPTA took over the entire commuter operations.

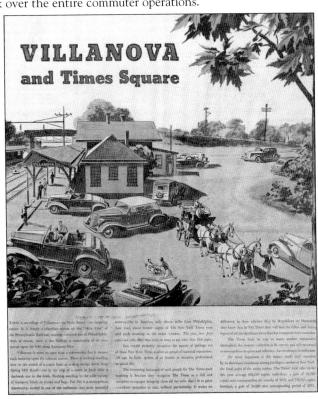

The *New York Times* ran a full-page advertisement for its own paper in a July 1936 issue highlighting its newspaper sales at Villanova Station. According to the caption, Villanova is "simply a suburban station on the 'Main Line' of the Pennsylvania Railroad running westward out of Philadelphia" and at this location the number of *Times* copies sold more than doubled in a year. Of particular interest is the subject matter of the advertisement. Commuters have just driven to the station and some are being dropped off—perhaps even one in a horse-drawn carriage. (Courtesy of *New York Times*.)

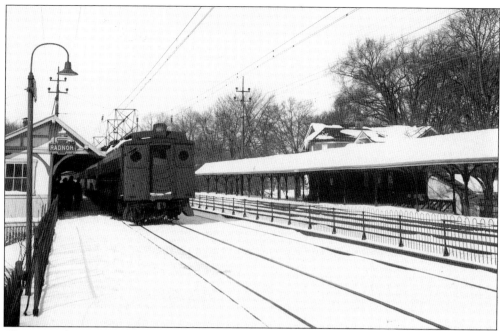

The sun is glaring off freshly fallen snow at the Radnor Station the day after a snowstorm hit the area in 1960. If the weather is not too severe to keep people home, passenger railroads often see a pickup in travel during and after poor weather as train travel tends to be safer and more reliable than other options. (Courtesy of Hagley Museum and Library.)

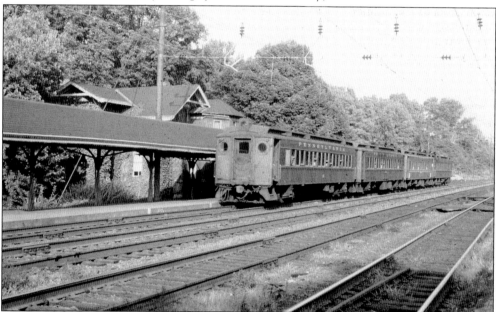

The station at Radnor was formerly called Morgans Corner, and the old Upton Station was called Radnor. But a switch was deemed necessary around 1870 by the PRR, so Morgans Corner became the new Radnor and the old Radnor became Upton. This view from September 1971 shows a westbound train arriving at the 1872 ivy-covered station. Notice some of the train windows are open on this warm day.

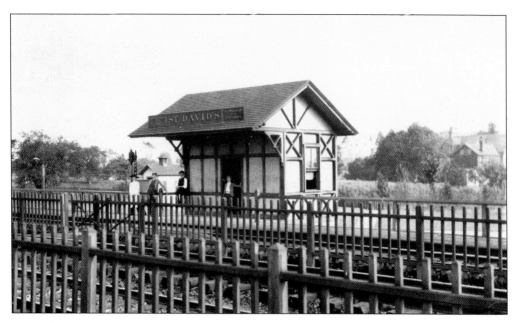

Trains first stopped at a small frame shelter at St. Davids Station in the 1880s, as shown in the photograph above. A short time after this c. 1890 photograph was taken, the shelter was replaced by a much larger station building, as seen below. It was formerly called East Wayne, and the station name "St. Davids" was taken by the PRR from St. David's Episcopal Church, also in Radnor Township. According to the *Philadelphia Inquirer*, "its name was transplanted there for business reasons from its real location 2 or 3 miles to the southwest of the railroad." This station was of similar design to the stations at Devon and Downingtown built during the same period. It was torn down in 1966. (Courtesy of the Archives of the Lower Merion Historical Society.)

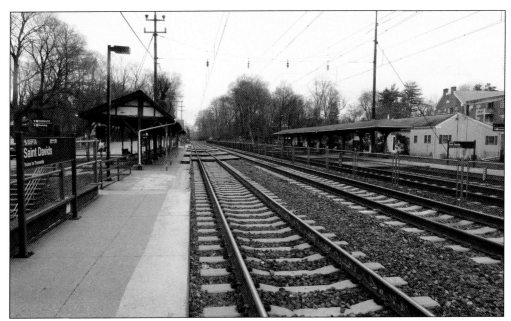

After St. Davids Station was demolished in 1966, it was replaced by a smaller utilitarian building. This building still stands and can be seen behind the eastbound shelter above (right). It is no longer in railroad use. Fortunately, the original canopy on the westbound side (left) of the tracks remains and still retains much of its original woodwork and details.

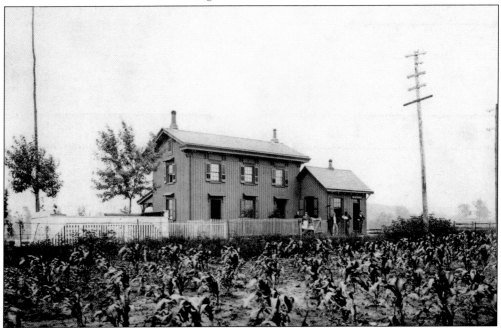

A very early station at Wayne is seen here around 1870. The station was originally called Louella, the same name of the large estate at this stop. Like other locations along the Main Line, Wayne first became a summer hotel and resort location for Philadelphians. Later on, many of these same summer residents built year-round homes at Wayne and used the railroad to commute to jobs in Philadelphia. (Courtesy of Library Company of Philadelphia.)

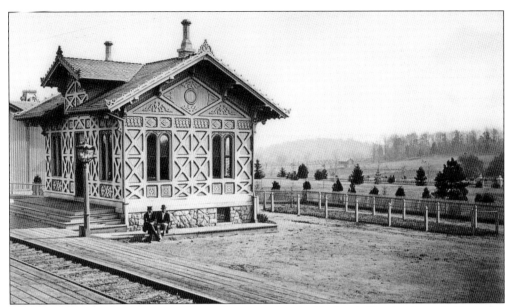

This is a photograph of the next Wayne Station taken by Frederick Gutekunst probably in the mid-1870s. It is purported that the structure came from the grounds of Philadelphia's Centennial Exhibition; however, no clear documentation supports this. The station was moved to Strafford in 1887 and is still in use. The previous Wayne Station could be the building next to it. Behind it, the top of the tower of Louella Mansion can be seen. (Courtesy of Library Company of Philadelphia.)

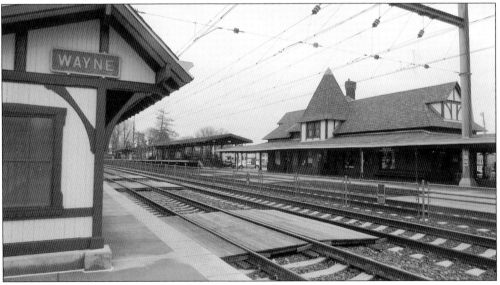

Today's Wayne Station is seen in this modern image. It was built in the mid-1880s as a response to the suburban "building boom" taking place along the Main Line. Because of other towns named Wayne in Pennsylvania, a proposal in 1885 to change the name of Wayne to "Windermere" was presented but rejected by the railroad as being too long. Another name suggested was "Ithon," but this was rejected by the community during a town meeting. Except for an expansion of the station to the east, Wayne Station looks much as it did when first constructed. In 2010, SEPTA completed a multiyear project at Wayne that included high-level platforms (to the east of the station), building restoration, and landscaping.

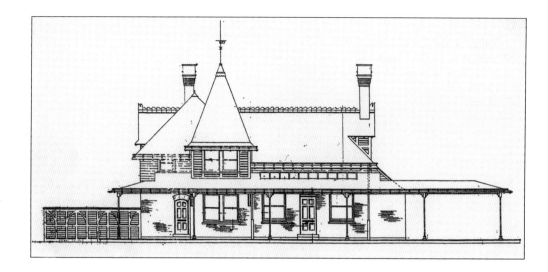

These are the original plans for the existing Wayne Station from the 1880s. The trackside plans (above) show the original station was smaller than it currently is, with the structure having been expanded eastward (to the left) at some point. The first-floor plans (below) have features typical of a number of Main Line stations. Not only did these stations have pleasant waiting areas for passengers, but they were also comfortable homes for the station agents and their families. As shown, a large waiting area included separate restroom facilities for men and women (though the men's was only accessible from the outside). Along with the ticket office, the agent had a kitchen and living room on the first floor. Three more bedrooms were on the second floor. The station was heated by a coal-fired furnace in the basement, but a large fireplace in the waiting room could also be used. (Both, courtesy of Amtrak.)

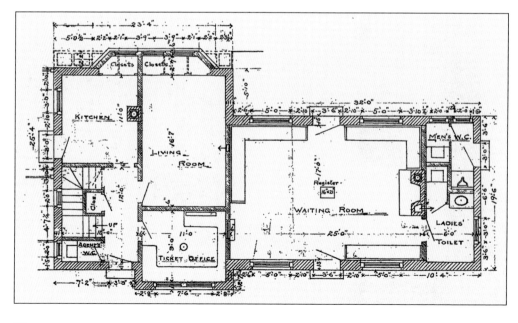

A number of well-known colleges and universities are located along the Pennsylvania Main Line, with the railroad providing an important service for both students and faculty. In the photograph at right taken by renowned railroad photographer O. Winston Link, three Haverford College students approach the inbound Haverford Station on a warm day in 1955. Below, a Villanova student helps his girlfriend off the train after it arrived at Villanova Station one evening in 1962. Several other institutions of higher learning also share their names with some of the Main Line stations, including Rosemont, Bryn Mawr, and Elizabethtown Colleges. (Right, courtesy of Quaker & Special Collections, Haverford College; below, courtesy of Villanova University Archives.)

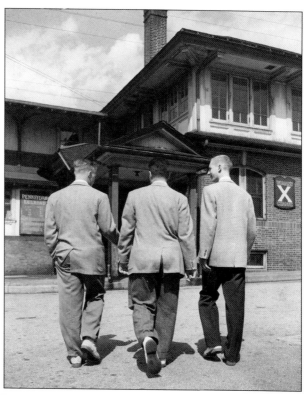

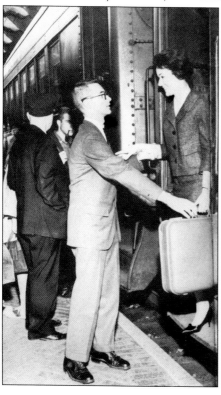

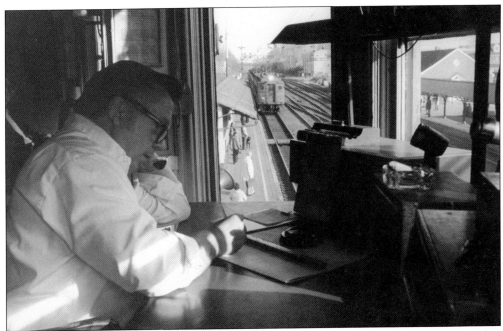

Common at many Main Line station locations were control towers. These towers were used to manage the signals and switches at railroad crossings, sidings, and junctions for sections of track. Those working in towers that directly overlooked the tracks could also visually inspect a train as it went by. The above photograph shows the interior of the tower at Bryn Mawr in the early 1970s. The view faces east and shows (on the left) the westbound platforms with a train approaching and (on the right) the eastbound main station. The interior of State Tower, located on the second floor of the Harrisburg Station, is seen below. The large switching machine controlled the interlockings between the station and Dock Street represented respectively as the left and right of the model board on the wall. (Above, photograph by Richard L.W. Ruess; below, courtesy of Library of Congress.)

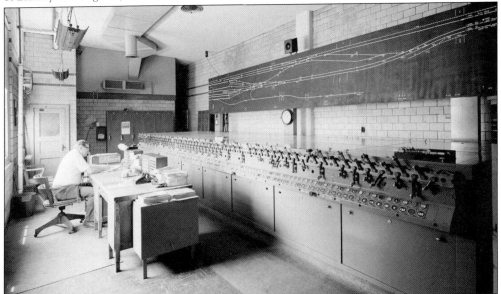

Seven

CHESTER COUNTY

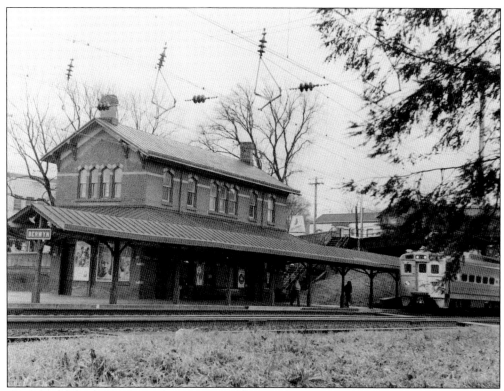

A train with both SEPTA and Penn Central logos pulls into Chester County's Berwyn Station on a cloudy day in November 1974. The eastern part of Chester County was the end of the traditional commuting Main Line, where most trains started or ended at Paoli. In recent history, the largest growth in Main Line ridership has been from stations in the central part of the county including Exton and Thorndale.

Strafford Station is one of the most unique stations still standing on the Main Line, but the building's origins are clouded in uncertainty. The station was originally located up the tracks in Wayne, where it was constructed in 1885. In 1887, it was disassembled, loaded onto flatcars, and reassembled just east of the old Eagle Station. It became the new Eagle Station but was renamed Strafford that same year. Tradition has it that this station was originally a building on the grounds of the 1876 Centennial Exhibition in Philadelphia, or that it was built from lumber from one of the buildings that was disassembled after the exhibition ended. Recent research, however, has not supported this assumption, and the building may have been designed and built specifically for the PRR at Wayne. (Both, courtesy of Library of Congress.)

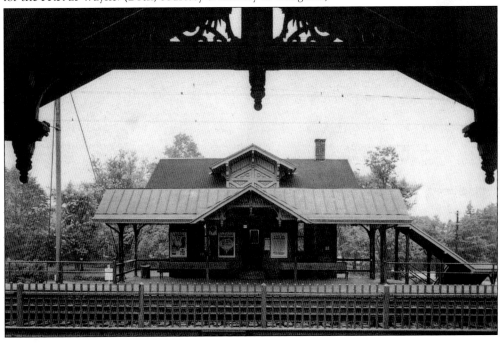

This photograph taken in the 1850s shows the Main Line tracks at Eagle Station, about a third of a mile west of the current Strafford Station. The station was described as "a two-story brick affair with the lower room divided into two parts, the westernmost being the passenger waiting room. This was heated in winter by a pot-bellied stove." Eagle was abandoned in 1887 when the then Wayne Station was disassembled and moved to become the current Strafford Station.

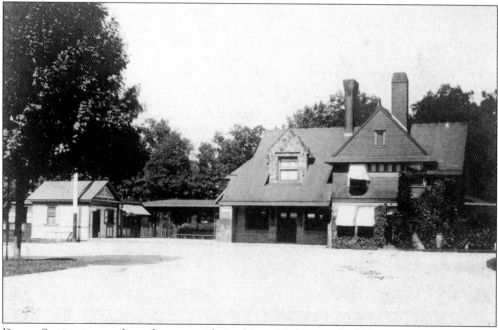

Devon Station is seen from the street side in this c. 1930 image. In 1881, Devon was called the "new town of the Pennsylvania Railroad" and in 1884 the *Philadelphia Times* reported, "there was nothing a year or two ago [at Devon] but farms and uncultivated land. Now it is one of the most fashionable and picturesque localities within half an hour's ride of the city, and a great colony of permanent residents has sprung up independent of the summer sojourners." (Courtesy of Chester County Historical Society.)

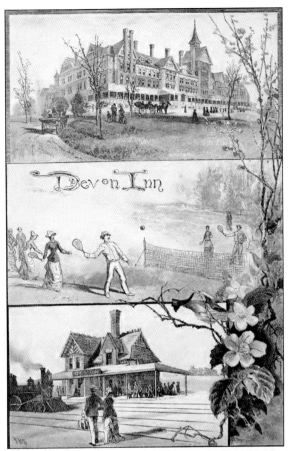

Leisure travel grew considerably with the expansion of the country's railroad system, especially in the latter half of the 1800s. To help meet this demand, the PRR published a yearly *Summer Excursion Routes* book listing dozens of popular destinations accessible by rail. The Main Line destinations of Devon (seen here) and Bryn Mawr were among the summer destinations in the annual publication.

Though the windows are boarded up on the second floor, the Devon Station building is still in use, with a SEPTA ticket agent on duty during weekdays. Devon is probably best known for the Devon Horse Show, a weeklong event held each spring. It is one of the oldest and largest equestrian competitions in the United States.

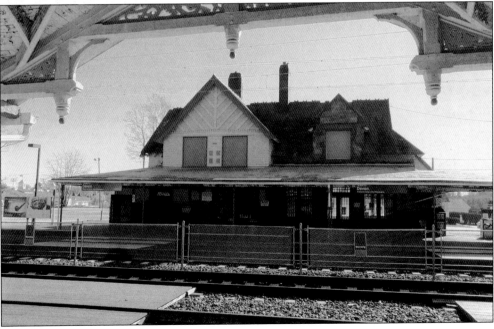

This photograph was taken around 1904 at the water pump in front of the Berwyn Station. The man on the left is railroad employee Joseph Bloomer, who has a uniform of either a conductor or station ticket agent. The man on the right is Adams Express employee William Bradley. (Courtesy of Tredyffrin Easttown Historical Society.)

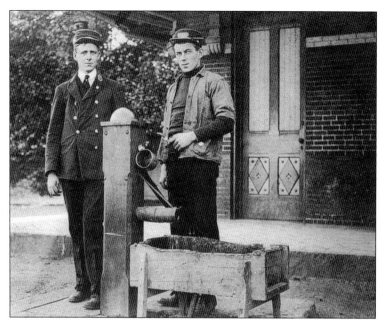

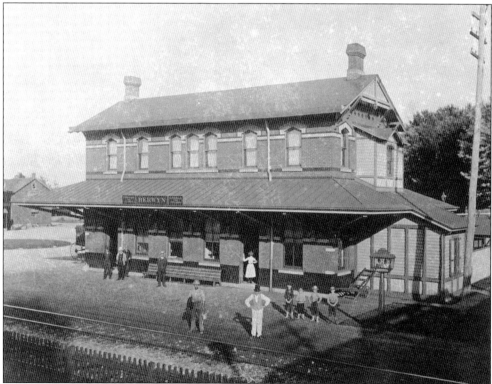

Local resident Julius Sachse took this photograph of the Berwyn Station from the Cassatt Avenue Bridge during the summer of 1888. Even four boys, three of whom are barefoot, stopped their activities so Sachse could photograph the station in what appears to be late afternoon. Commonly seen in many station photographs of this era are the standard PRR station sign, gas lamps, and luggage cart. (Courtesy of Tredyffrin Easttown Historical Society.)

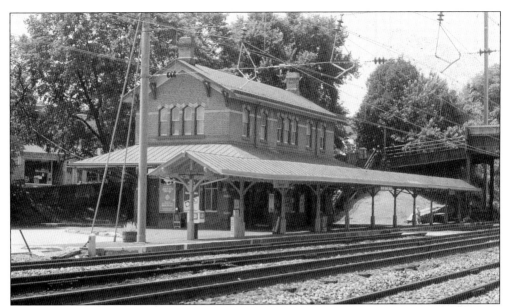

A lone passenger waits for a midday train at Berwyn on a summer day in 1984. Formerly called Reeseville, the village, which straddles Tredyffrin and Easttown Townships, changed its name to Berwyn in 1877. Early on, Berwyn was one of a number of Main Line stops that accommodated city residents looking to escape the summer heat of Philadelphia. The Wynburne was a small hotel near the station, which advertised in 1887 as having "electric call bells, steam heat in every room, open fire places, and pure spring water."

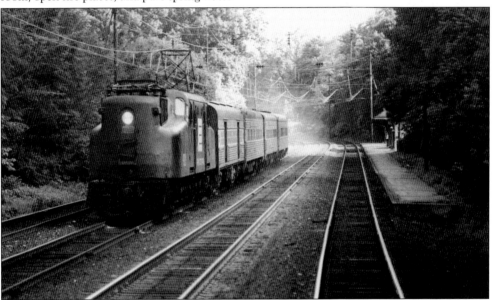

A westbound Amtrak train with a GG1 locomotive glides down the Main Line on the inside track in this early 1970s photograph. Between 1934 and 1943, one hundred thirty-nine GG1s were built for the PRR for use on the electrified lines of the Northeast Corridor and Main Line. The GG1 was a reliable locomotive. With its fast acceleration and ability to haul long passenger trains, it was a mainstay for the PRR and successor railroads (including Amtrak) well into the 1980s. (Photograph by Richard L.W. Ruess.)

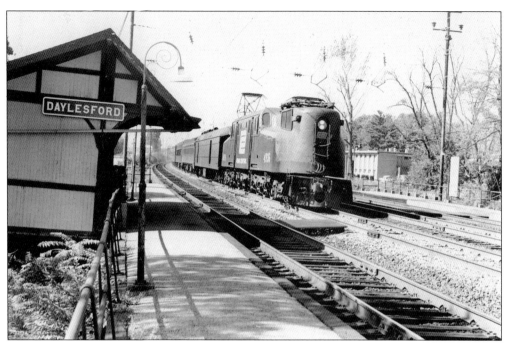

Daylesford is situated between Berwyn and Paoli, and its first shelter was built by the PRR in 1890. It never had an enclosed building. In the early 1900s, developers promoted Daylesford in hopes of creating a community similar to other Main Line locales, but the plans never materialized as they hoped. Nevertheless, Daylesford has remained a stop but with smaller average daily ridership than most, especially stops east of Paoli. Seen above is an eastbound Penn Central train passing Daylesford in 1969. Below, SEPTA passengers watch Amtrak's Pennsylvanian roar past Daylesford on the inside track as they wait for their local train to Philadelphia to arrive on the outside track. This newer shelter replaced the wooden one in the photograph above in 2000.

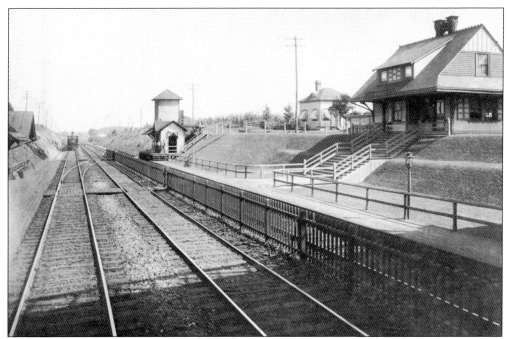

Pictured above is Paoli Station as it looked in the 1890s. Paoli is an unincorporated community straddling Tredyffrin and Willistown Townships. In the 1760s, an inn located in the village on the old Lancaster Pike was named for the Corsican general Pasquale di Paoli. Like many communities along the Main Line, Paoli became the summer residence for Philadelphians looking to escape the city. Later on, fast and frequent train service enabled year-round residents to commute to Philadelphia on a daily basis. Below, a photograph taken from a similar angle shows a two-car SEPTA Paoli Local in 1981.

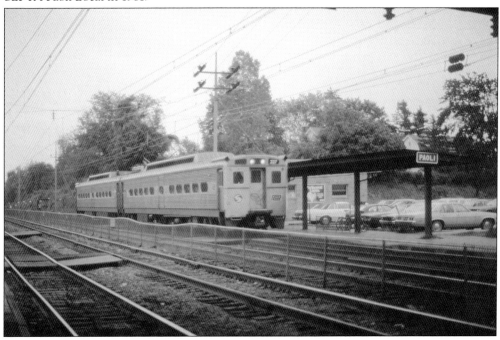

Penn Central conductor Bender smiles at his passengers as the last ones depart his train at Paoli in this photograph taken in the early 1970s. The crew is operating a Paoli Local, which ran between this eastern Chester County community and Philadelphia—first to Broad Street and later to Suburban Station. In 1915, the PRR electrified the Main Line as far west as Paoli and it was here for many years that most local commuter trains began or ended their runs. Seen below is the train yard just west of Paoli Station in 1979. This area was a busy place where train cars were stored and maintained, and where they reversed direction for the return trip to Philadelphia. The switching tower that controlled the interlocking at Paoli is seen on the left. In the distance is the Paoli substation where electricity was stepped down from 40,000 to 11,000 volts to feed the overhead power lines (catenary). (Right, photograph by Richard L.W. Ruess.)

These photographs taken from the same general location show the former and current stations at Paoli. The former station was built in a Victorian style in 1893 and sat on a small hill with steps leading down to the tracks. Later, a canopy was built and the steps covered. In 1953, the existing nondescript station at Paoli was built in the same location. The hill was flattened and the station constructed level with the tracks. Much-needed parking was added between the station and Lancaster Avenue. The roofs of the current outbound shelter obscure the tracks in the photograph below. (Above, courtesy of Tredyffrin Easttown Historical Society.)

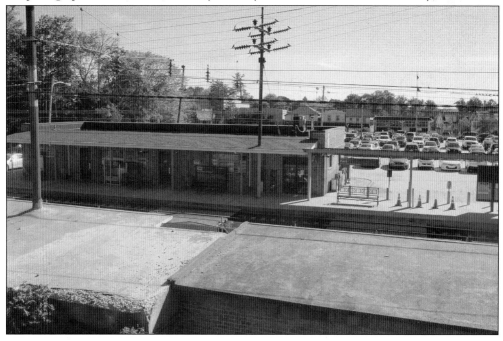

This PRR timetable from 1958 shows the daily trains to Philadelphia from Paoli. Each weekday, 41 trains ran from this suburban community in eastern Chester County to Center City, some only minutes apart from each other during peak periods. Today, SEPTA operates approximately the same number of weekday trains, though some start earlier and some start later in the day. In addition, Amtrak runs 14 trains from Paoli to Philadelphia each weekday.

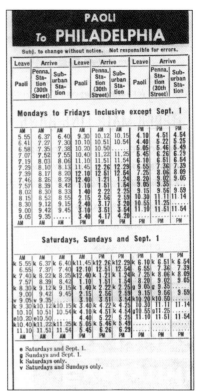

This four-car Penn Central commuter train just pulled into the Paoli Station for an early-afternoon, off-peak run to Philadelphia in May 1972. Hundreds of these MP54 cars were built for the PRR beginning in 1915, the same year the Main Line was electrified to Paoli. The last ones were retired from Philadelphia suburban service in 1981 under SEPTA.

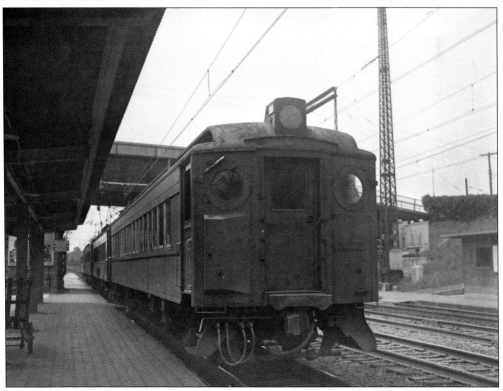

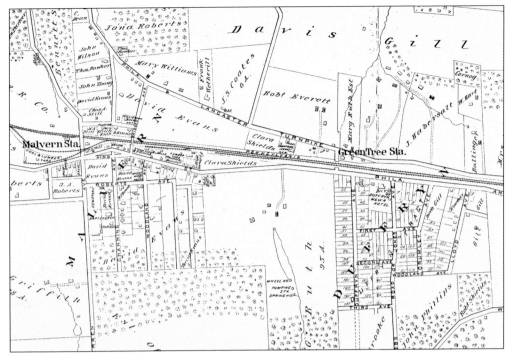

This map was published in 1887, the same year a station was built between Paoli and Malvern. This location was known for years as Duffryn Mawr, which is Welsh for "great valley," but the new station was called Green Tree after a local tavern. In fact, after the station was completed, the station sign that read "Duffryn" had to be taken down and repainted with "Green Tree" after the new name was made official by the PRR's board of directors. The station was of a similar design to the station farther down the tracks at Frazer.

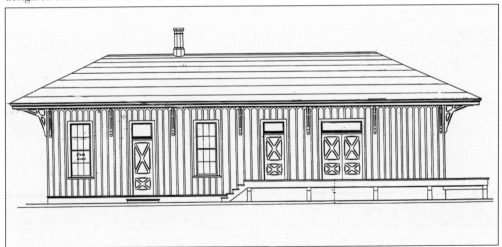

These trackside elevation plans are for the combined passenger and freight depot that was built at Malvern in 1873. It was the same year the name of the locale was changed from West Chester Intersection to Malvern. The door on the left was the entrance to the passenger waiting room and ticket office; off the main waiting room was a separate waiting room for women. The middle door led to the baggage room, which had interior access through the agent's office. The large door on the right was for the warehouse. The depot burned down in 1892. (Courtesy of Amtrak.)

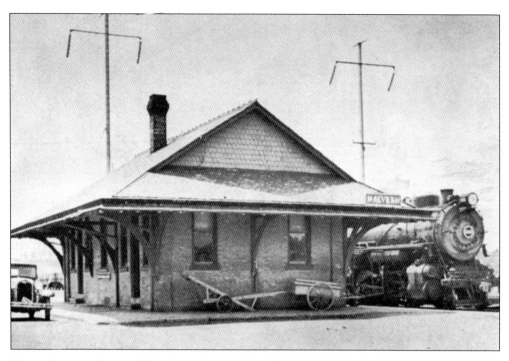

These photographs are of the current station in Malvern. It was built in 1893, replacing one that was destroyed by fire a year earlier. The above photograph shows the east side of the station around 1939, soon after the PRR completed electrification of the Main Line from Paoli to Harrisburg. The below photograph is a recent view of the station looking east. Currently, Malvern is the westernmost station on the Main Line with Sunday SEPTA service. Malvern was once a regular Amtrak stop, but Amtrak service ended here in 1996. (Above, courtesy of Chester County Historical Society)

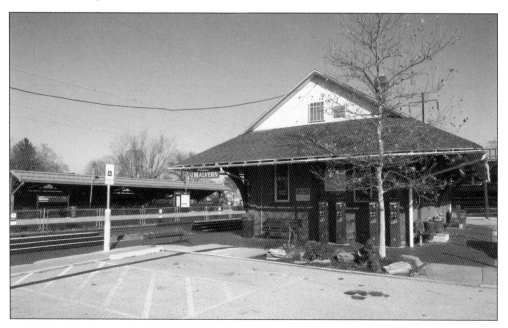

WEST CHESTER AND PHŒNIXVILLE.

Dis.	NORTHWARD	WEEK-DAYS.				SUNDAYS.		
		234	236	288	290	392	394	396
	Leave.	A M	A M	P M	P M	A M	P M	P M
.....	WEST CHESTER......	6.48	9.01	1.10	5.33	8.56	12.56	4.26
0.5	Maple Avenue.........	f 6.50	f 9.03	f 1.12	f 5.35	f 8.58	f 12.58	f 4.28
1.4	Fern Hill	f 6.53	f 9.06	f 1.15	f 5.38	f 9.01	f 1.01	f 4.31
2.8	Green Hill......	f 6.56	f 9.09	f 1.18	f 5.41	f 9.04	f 1.04	f 4.34
3.8	Kirkland	f 6.59	f 9.12	f 1.21	f 5.44	f 9.07	f 1.07	f 4.37
5.1	Morstein	7.02	9.15	1.24	5.48	9.10	1.10	4.40
6.8	FRAZER. { Ar.	7.07	9.20	1.29	5.53	9.15	1.15	4.45
	{ Lv.	7.18	9.27	1.43	6.00	9.27	3.00	5.45
8.6	Swedesford Road ...	f 7.22	f 9.31	f 1.47	f 6.04	f 9.31	f 3.04	f 5.49
9.5	Bacton.....................	f 7.24	f 9.33	f 1.49	f 6.06	f 9.33	f 3.06	f 5.51
10.7	Sidley	f 7.27	f 9.36	f 1.52	f 6.09	f 9.36	f 3.09	f 5 54
12.2	Devault	7.32	9.40	1.56	6.13	9.40	3.13	5.58
13.3	Aldham	f 7.37	f 9.43	f 1.59	f 6.16	f 9.43	f 3.16	f 6.01
15.0	Pickering	f 7.41	f 9.46	f 2.02	f 6.19	f 9.46	f 3.19	f 6.04
16.1	Harveyville............	f 7.44	f 9.49	f 2.05	f 6.22	f 9.49	f 3.22	f 6.07
16.8	Nutt's Avenue.........	f 7.47	f 9.51	f 2.07	f 6.24	f 9.51	f 3.24	f 6.09
17.7	PHŒNIXVILLE.........	7.50	9.54	2.10	6.27	9.54	3.27	6.12
	Arrive.	A M	A M	P M	P M	A M	P M	P M

In 1880, the junction of the Pennsylvania Railroad and West Chester Railroad was moved west to Frazer from West Chester Junction (now Malvern). Connections could be made from the Main Line south to West Chester or north to Phoenixville. This northbound timetable from 1913 shows four weekday and three Sunday trains.

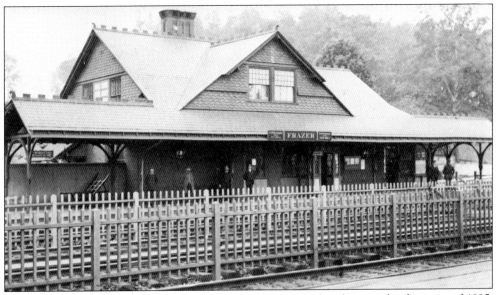

Railroad employees and others stand outside Frazer Station in this photograph taken around 1895. The station stop, formerly called Garrett's Siding, was built in 1886 soon after the intersection of the West Chester Branch was relocated from Malvern to this location. Frazer was also the point at which the Phoenixville Branch left the Main Line. Frazer closed around 1960 and was later torn down.

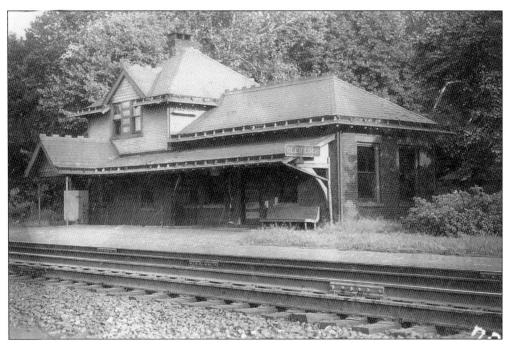

The undated photograph above shows Glen Loch Station, built in 1906. The PRR created a local uproar in 1934 when it proposed eliminating the station agent position, at that time held for many years by Arthur Bagshaw. Also the postmaster, Bagshaw was called the "community's most indispensable citizen" due to his community service. At a Public Service Commission hearing, one resident even stated that "Glen Loch husbands feel that their families are safe and secure while they are away on business as long as Bagshaw is there." The station eventually did close, upon Bagshaw's retirement years later, but Glen Loch held on as a stop until about 1960. The station building remained but eventually fell into significant disrepair. Fortunately, it was beautifully restored around 2005 and is now a private home, seen below from the street side. (Above, courtesy of the family of Arthur Bagshaw.)

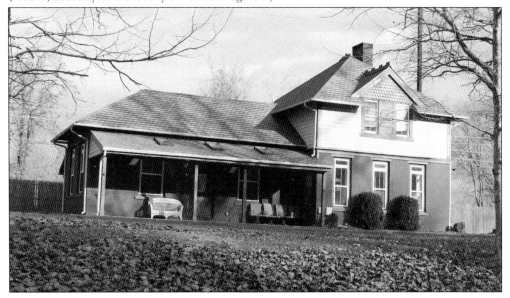

The Ship Road underpass seen above was at the station location with the same name, built in 1889. The name of the road came from the Ship Tavern located nearby on Lancaster Pike. The underpass seen in the background is for the long-gone tracks of the parallel low-grade freight line. Remnants of the station platforms are still visible as seen below. In 1889, nothing existed around the station to justify its construction, but the PRR was probably influenced by Dallas Sanders, who bought a large piece of land in the area two years before with the intention of selling off parcels—but he would "only sell to such as would make pleasant neighbors," as reported in the *Philadelphia Inquirer*. In 1891, there was a rumor that Ship Road Station would be renamed Loch Gucker Station in honor of PRR superintendent Thomas Gucker, but this never transpired.

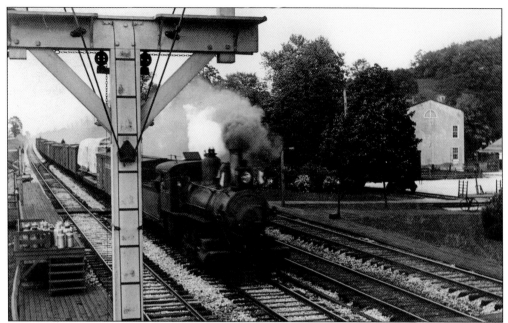

Taken around 1900, the photograph above faces east and shows the station at Whiteland (now Exton). On the left are the westbound passenger platform and the standard, raised milk platform for the daily milk train. A portion of the roof of the main station can be seen at right along with the ever-present baggage cart. An early description of Whiteland describes a station that was "designed to facilitate the traffic of the country adjacent, and has few points of interest." An Amtrak train is seen leaving Exton in the photograph below, taken from the same vantage point today. Traffic at Whiteland/Exton fell off considerably during the mid-20th century, but picked up starting in the 1980s as a commuter station resulting from significant residential growth in central Chester County. (Above, courtesy of Hagley Museum and Library.)

At Exton Station, passengers watch a Philadelphia-bound Amtrak train pull into the station on a fall weekend. Unlike other large Chester County stations such as Paoli and Downingtown, Exton Station is not located in a walkable town center and is generally a park-and-ride facility. But it is one of the busiest stations west of Philadelphia due to its easy access from much of central Chester County. In 2015, work began to improve Exton Station with an indoor station building, high-level platforms, and expanded parking.

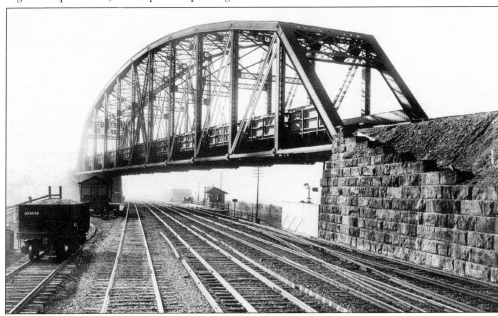

This image taken by railroad photographer William Rau in 1904 shows the newly constructed flyover of the Philadelphia-Thorndale low-grade freight line crossing the Main Line tracks at Whitford. The low-grade line was built to bypass the congested and steep grades of the Main Line west of Philadelphia. The view faces east, and the Whitford Station shelter is visible in the background. (Courtesy of the J. Paul Getty Museum.)

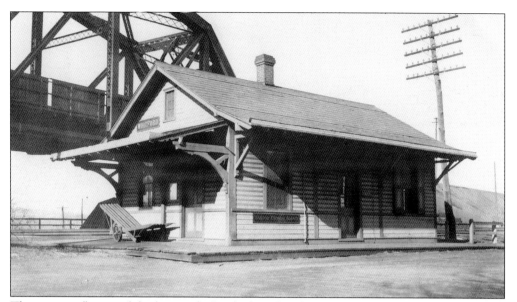

The massive flyover of the low-grade freight line dwarfs the small station at Whitford in this early photograph. The station was built in 1907, replacing an even smaller shelter at this stop. The station building had a small waiting area for passengers (still in use) as well as an office for the Railway Express Agency. In 1984, it was listed in the National Register of Historic Places. (Courtesy of Chester County Historical Society.)

This long-range view shows how the flyover of the old low-grade freight line at Whitford dominates the station area. In the 1800s, the station was called Oakland, and the Oakland Hotel was situated approximately where the commercial building is on the left. The hotel, which had its own railroad siding, was described in an early travel guide as "a desirable resort for Philadelphians to board during summer months being a high and healthy situation and commanding one of the most extensive views in the great Chester valley."

In 1888, a Philadelphia real estate company tried to develop nearly 400 acres west of Downingtown into a community of summer homes. The station at this location was originally called Valley Creek, but the name was changed to Bradford Hills after the name of the new development. Even a hotel was proposed for the location. This advertisement and others like it appeared in Philadelphia newspapers during the summer of 1889 but had little effect. Only a few homes were built and the envisioned community never materialized. Bradford Hills, however, continued to be a stop along the Main Line until 1960.

Remnants of the platforms can still be seen at the old Bradford Hills Station despite not seeing a train stop in over 50 years. The former station is located at the Boot Road underpass (the safety railing over Boot Road can be seen on the left). This photograph shows Amtrak's Pennsylvanian going east past the station after slowing down in the curves that go through the hills just east of Downingtown.

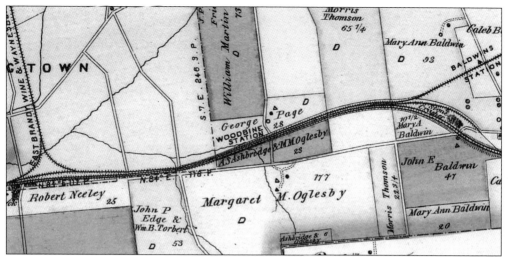

Woodbine Station was 1.5 miles east of the Downingtown Station and served the agricultural community of East Caln Township. It was located where Woodbine Avenue crossed the Main Line tracks. The crossing was closed in the 1920s because, as noted in the *Coatesville Record* at the time, "a distinct hazard exists, particularly to heavy and slow-moving vehicles" from the 85 trains the PRR ran through the area on an average day. It is unclear when the station closed. No trace of it exists today.

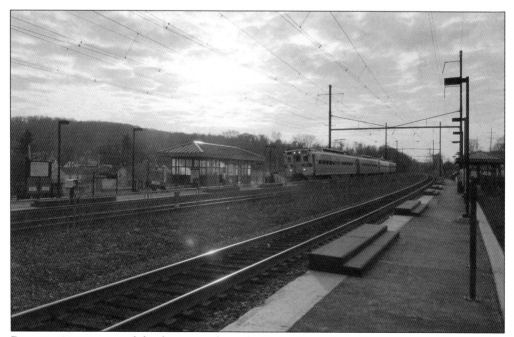

Downingtown is one of the few stops along the Main Line where the current station is in the same location as the original station for the Philadelphia and Columbia Railroad. This modern view looks west as an eastbound SEPTA train comes into the station on a late afternoon run to Philadelphia. The eastbound passenger shelter replaced the main station building that stood for nearly 100 years when it was destroyed by fire in February 1992.

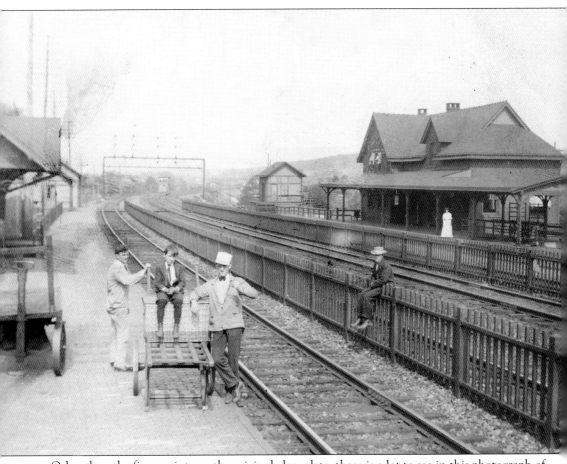

Other than the fingerprints on the original glass plate, there is a lot to see in this photograph of the Downingtown Station area taken from the platform of the Railway Express office around 1908. The man in the center appears to be wearing a Railway Express cap and may have just wheeled a shipment onto the platform to await (along with some friends) the next westbound train. Safety rules were substantially less stringent than they are today, as demonstrated by the man sitting awkwardly on the track fencing. The ticket agent living in the station at the time was Robert Russell. His wife, Mary, could be the one seen on the opposite side of the tracks, having just stepped out of the station building for the photographer. The 1892 station building was actually closer to the tracks than seen here. In 1905, it was moved 17 feet to the south to make room for a track to access the rail yard to the west of the station. Also seen in the distance is the switching tower, which controlled the interlocking between the station and the Brandywine River viaduct. (Courtesy of Downingtown Area Historical Society.)

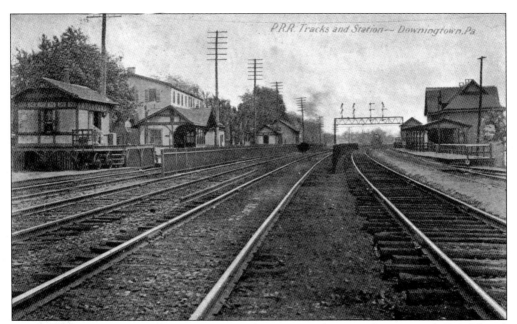

Downingtown's station facilities are seen in these postcard images from around 1910 (above) and around 1915 (below). Both views look east and show the main station on the right and the westbound shelter on the left. Above, an individual is standing on the platform of the Railway Express office, the same platform from which the image below was taken. The two-story building behind the westbound shelter is the Pennsylvania House hotel. In the early years of the railroad, a PRR publication described Downingtown as "one of the most noted 'eating stations' between Philadelphia and Pittsburgh." It added that "the familiar announcement, 'Downingtown, four minutes for refreshments!' was a welcome sound to many hungry travelers." (Below, courtesy of Jay Byerly.)

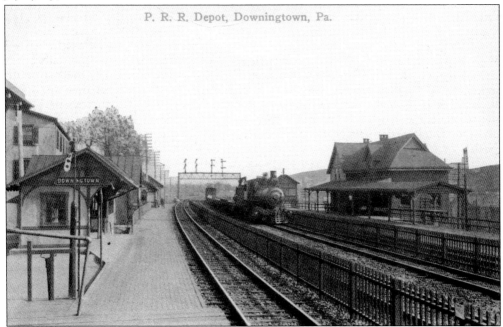

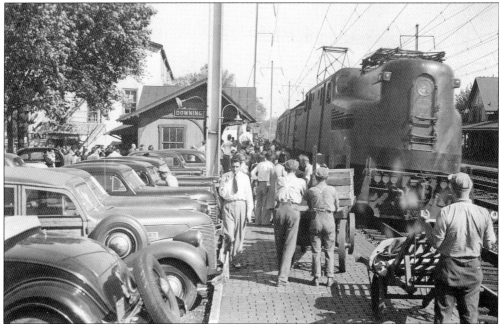

The photographer was standing on the Railway Express platform at Downingtown when he captured this shot of a westbound PRR train pulled by a GG1 locomotive. Two men with a large cart loaded with boxes and one with a smaller cart with mail pouches try to make their way to an open door on the train. The crowd meeting the train was quite large and extended the length of the platform and back to Lancaster Avenue on the left. Unfortunately, further research has not been able to identify the event that captured the attention of so many in Downingtown on this warm afternoon in 1941. However, the image does provide a good glimpse of the station area, including the outbound shelter and the Pennsylvania House hotel in the background. Below, a modern photograph taken from the same position on a balmy December day shows an arriving Amtrak Keystone train leading with a cab car as the Downingtown High School West marching band goes by on Lancaster Avenue during the town's annual Christmas parade. (Above, courtesy of Downingtown Area Historical Society.)

Above is a front view of the Downingtown Station plans from 1893. Along with the waiting area, ticket office, and baggage room, the first floor had a sitting room and bedroom for the station agent. A kitchen and living room were at the basement level. Four additional bedrooms were on the second floor. Downingtown's seal, shown below, illustrates the importance of the railroad to the borough. It was one of the original stops on the Philadelphia and Columbia Railroad. In 1861, Lincoln's inaugural train stopped here for wood and water. One newspaper said Lincoln's car was "besieged by a mob of Downingtowners, who called for the President elect . . . he appeared for a moment on the rear platform, and was greeted with immense cheering." Lincoln's funeral train also stopped at Downingtown to refuel in April 1865. When the train halted, a crowd "quietly gathered around the rear of the train, and stood with their heads uncovered." (Above, courtesy of Amtrak.)

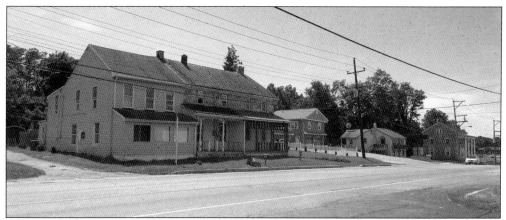

The village of Gallagherville is about a mile west of Downingtown in Caln Township. Though the area has blended with Downingtown and Thorndale, for many years it was a distinct location with its own railroad station. There was also a hotel as well as stores, miscellaneous businesses, and a number of residences on the strip of land between Lancaster Pike and the railroad tracks. It is unclear where the railroad station once stood (service ended in 1907 and the station was later demolished) but it was very near these homes and businesses on the south side of Lancaster Pike (Route 30).

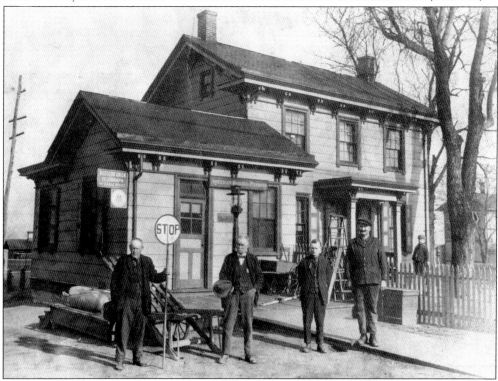

A photograph taken by PRR station agent N. Hayes Jones shows the Thorndale Station around 1921. Jones lived with his family in the house attached to the station. The man second from the left may be William Timbler, a railroad telegraph operator. The man second from the right is Clarence Buchanan, a railroad laborer. The man on the left with the stop sign and the man on the right are not identified. Jones's son William is in the background. The eastbound shelter on the south side of the tracks is visible in the background. (Courtesy of Caln Historical Society.)

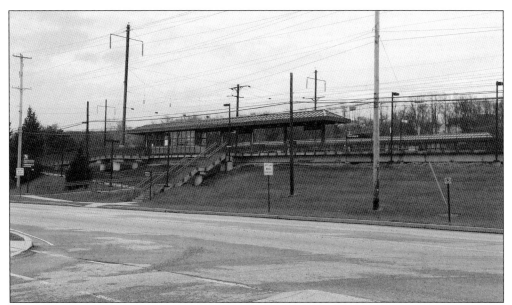

The newest station on the Main Line was built at Thorndale and is the terminus for SEPTA's Paoli/ Thorndale Line. Service began here in 1999. This is a view of the platform and canopy on the north side of the tracks along Lancaster Pike (Route 30). After letting off their final passengers, westbound SEPTA trains reverse direction at Thorndale and then head eastbound either on another scheduled run or to return to SEPTA's yard at Frazer.

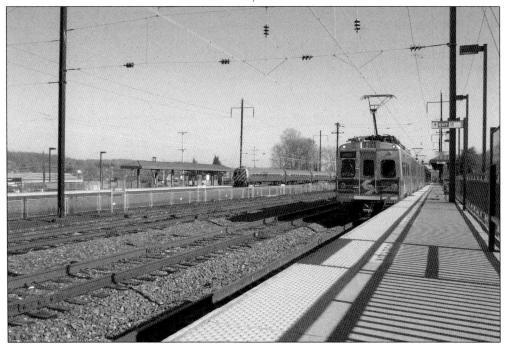

A westbound SEPTA train just ended its run after crossing over to the south side platform at Thorndale Station on a Saturday afternoon. The engineer will walk the length of the train and prepare it to head back to Philadelphia. Meanwhile, following right behind was a westbound Amtrak Keystone train leading with a cab car.

The photograph above shows the USO (United Service Organizations) canteen and lounge at the Harrisburg Station in 1943. Because most stateside troops traveled by train during World War II, canteens like this one were often set up in larger train stations around the country, often with décor in stark contrast to the more formal station architecture. The PRR offered facilities to the USO at a number of stations, such as Broad Street and Thirtieth Street in Philadelphia, Scranton, Trenton, Newark, and Penn Station in New York among others. The postcard seen below was free to use and send for armed forces personnel and would often be the first correspondence after leaving home. This one was sent by a soldier from Thirtieth Street Station to his girlfriend in Kutztown, Pennsylvania. (Above, courtesy of Library of Congress.)

USO Lounge, Broad St. Station, Philadelphia

USO Lounge, Pennsylvania Sta. (30th St.), Philadelphia

Corner of the USO Lounge, Pennsylvania Station, New York City

USO Lounge, Pennsylvania Station, Newark, N. J.

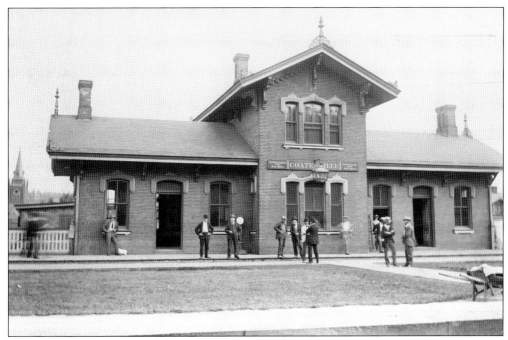

It is unclear when this trackside photograph was taken of the Coatesville Station, but the penny scale in the background may date it to around 1890. It probably was not taken after 1895, which was the year four tracks reached Coatesville. At least one of the tracks would have been visible closer to the station where the lawn is seen. (Courtesy of Graystone Society.)

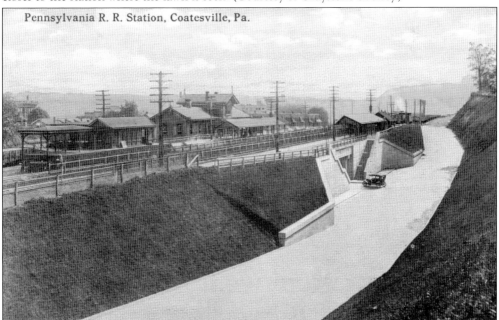

This view of the Coatesville Station shows the newly completed (1911) Third Avenue underpass, which provided access to properties north of the tracks. For safety reasons, the PRR eliminated as many grade crossings as it could along the Main Line with either bridges or underpasses. The main station and passenger shelter are at center. The freight station is on the left.

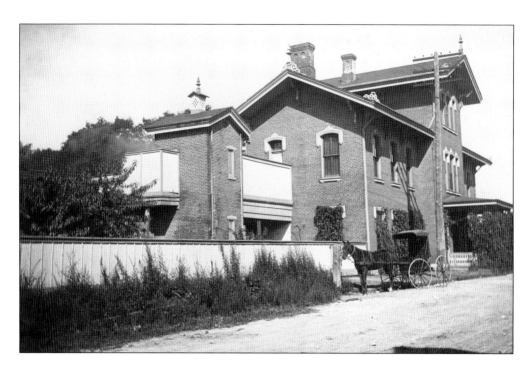

The c. 1900 photograph of the 1869 Coatesville Station above was taken on what is now Fleetwood Street. The station agent's home and office were on the first floor, which might explain the ivy covering the street-level windows and porch. The structure on the left is a baggage elevator to track level, which was taken down a few years later. The station remains today, as seen in the photograph below taken from a different angle. Both ends of the building were extended in the early 1900s, but the center gable and much of the ornamentation were eventually removed. It is currently unoccupied. (Above, courtesy of Graystone Society.)

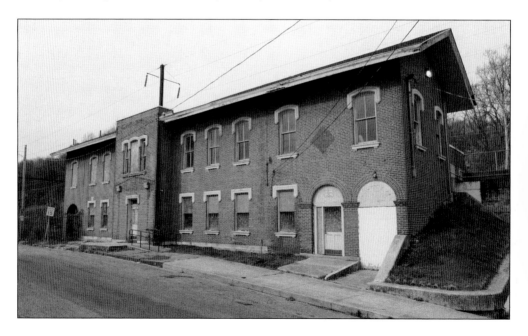

In this view looking east, the Coatesville Station in 1973 looks much the same as it does today, but the westbound shelter has been replaced with a smaller utilitarian structure. All four tracks were still in use as there was still significant freight traffic on the Main Line at this time.

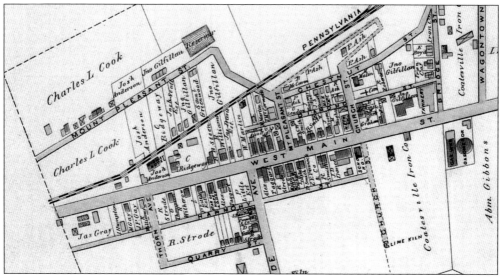

The western end of Coatesville was known for a time as Midway, as it was the halfway point on the original Main Line between Columbia and Philadelphia. An 1855 guide to the PRR describes Midway as a "small neat village and station near the high bridge." This map from 1883 shows the Midway Hotel on West Main Street built parallel to the tracks (the first Midway Hotel at the same spot burned down in 1854). The original Midway station may have been in the first hotel or very close by. The second station in Coatesville was built by the PRR in the center of town in 1858 between First and Second Avenues.

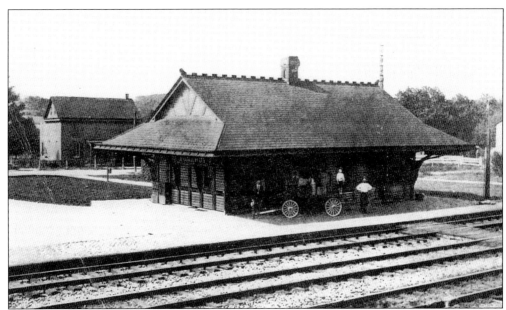

Above, around 1910, is the PRR station in the village of Pomeroy located between Coatesville and Parkesburg. The station stop dates to before the Civil War, when it was called Chandler's, after William Chandler, the owner of several businesses in the village. However, the post office in the village, which was established in 1864, was called Buck Run. To avoid confusion, local resident John J. Pomeroy suggested the current name to honor his family. The village officially became Pomeroy in 1866. It was also the location of the connection with the Pennsylvania and Delaware Railroad (later the Pomeroy and Newark Railroad), as seen below. Trains coming north from Delaware would use the wye in the tracks to reverse direction in order to head back south without interfering with operations on the Main Line. The train in this photograph is using the left wye. The Main Line tracks are in the background across the length of the photograph. (Both, courtesy of Sadsbury Township Historical Society.)

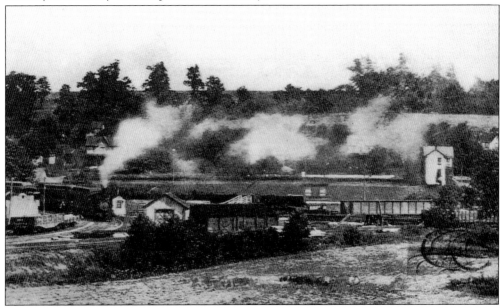

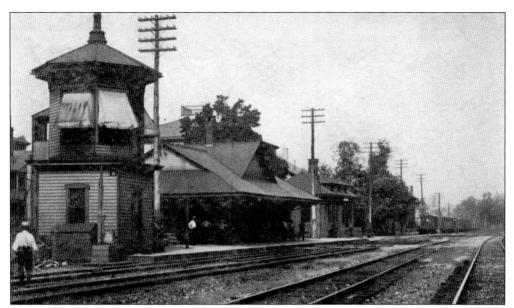

This photograph with a view looking east was probably taken around 1900 and shows the switching tower and station on the north side of the tracks at Parkesburg. This station was built in 1896 but was replaced only 10 years later by one farther down the tracks in conjunction with the construction of the low-grade freight line. (Courtesy of Chester County Historical Society.)

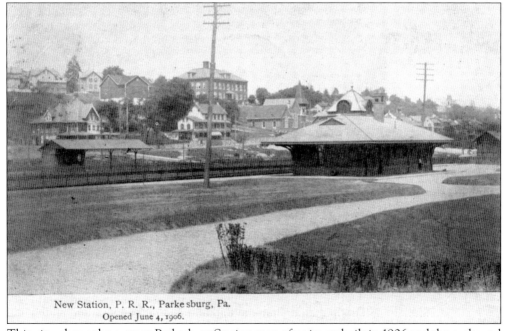

New Station, P. R. R., Parkesburg, Pa.
Opened June 4, 1906.

This view shows the current Parkesburg Station soon after it was built in 1906 and the outbound shelter on the north side of the tracks. The small freight depot can be seen at right. The pyramid-shaped cupola on the station building is long gone. Many of the structures on the north side of town are visible, including the school and First Methodist Episcopal Church.

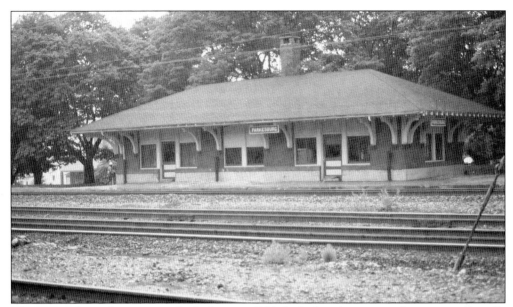

This image shows the station at Parkesburg in 1984. Parkesburg's station today is generally well-maintained but is not open for passenger use (the building closed in 1962). For trains heading west, it is the last Amtrak stop in Chester County, and the distance between Parkesburg and Lancaster (24 miles) is the largest gap currently on Amtrak's Keystone line. A scene in the 1985 film *Witness* was filmed at the Parkesburg station.

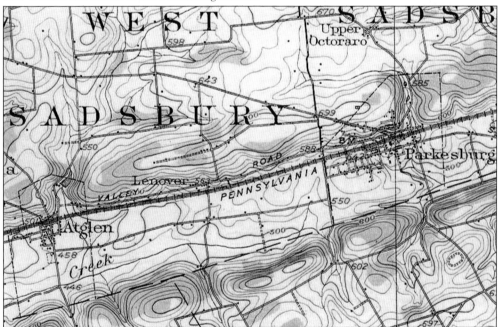

In 1886, the PRR began stopping at Lenover, situated between Parkesburg and Atglen. Anchored by farm machinery maker John N. Chalfant & Sons, the hamlet was especially prosperous in the late 1800s. The company proposed a post office be established in the village but could not use the name Chalfant as it was being used by another town in Pennsylvania. John Chalfant's son Howard suggested the name Lenover. (US Geological Survey.)

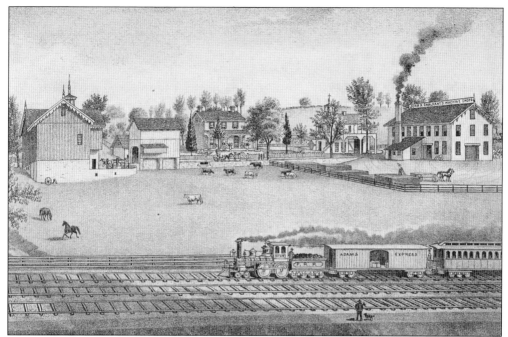

In 1890, Lenover made national news when an individual (purportedly from an English cotton syndicate) purchased 600 acres nearby in order to construct the largest cotton mill in America. With thousands of expected workers, Lenover was expected by many to grow to be one of the largest towns on the Main Line. Plans for the area were drawn up, including hundreds of lots for potential home sites. However, the entire plan was soon discovered to be a scam. The cotton syndicate was a ruse, and the "agent" intended to take the down payments for the homes and leave the area.

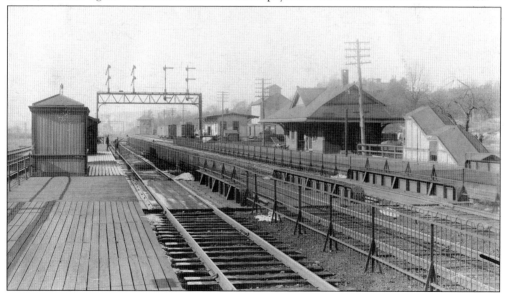

Formerly called Penningtonville, Atglen was the westernmost stop in Chester County before the railroad turned north through Christiana and Gap and into the heart of Lancaster County. This station was built in 1905 in conjunction with the construction of the PRR's low-grade freight line, the tracks of which can be seen at far left. (Courtesy of Chester County Historical Society.)

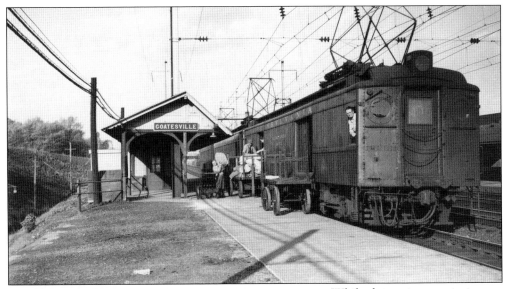

While the engineer waits in the cab, workers unload mail bags at Coatesville on a late June afternoon in 1948. The value of moving mail by train was recognized by the Post Office Department as early as the 1830s and continued until 2004 when Amtrak stopped carrying mail and express. Railroad stations also served as post offices, especially in rural areas, where in some cases the agent was also the postmaster. In larger cities, postal facilities often had rail access such as the large post office building (now in other use) located across from Thirtieth Street Station in Philadelphia, or the Harrisburg Station as seen in the 1981 photograph at left that shows a mail conveyor connecting a loading platform at the station with the then adjacent Harrisburg Post Office facility. (Above, courtesy of Chester County Historical Society; left, courtesy of Library of Congress.)

Eight

LANCASTER COUNTY

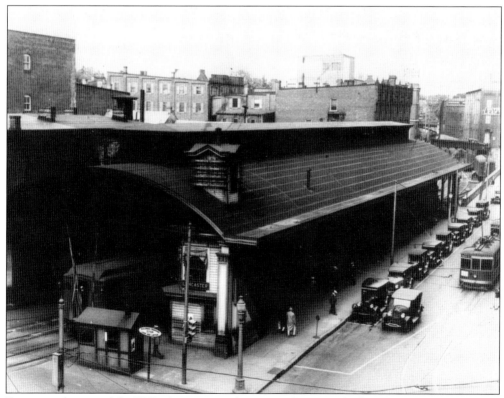

During peak years of the PRR, there were eight stations between the last stop in Chester County and the city of Lancaster. Now there are none, and the distance between Parkesburg in Chester County and the city of Lancaster (24 miles) is the longest nonstop section presently on the Main Line between Philadelphia and Harrisburg. This is Lancaster's downtown station in the 1920s.

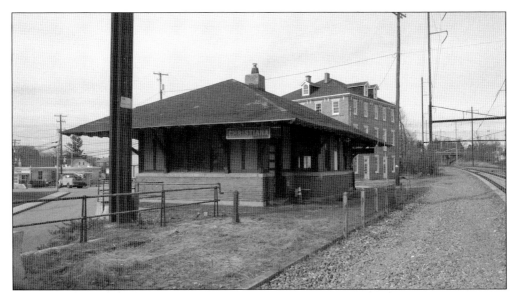

Few station buildings at abandoned stops are still standing along the Main Line, but Christiana's is one of them. It was built in 1912 and was the first westbound stop in Lancaster County. Christiana Station avoided demolition but sat for many years in a rundown state. Fortunately, it has been restored through the efforts of a local preservation group.

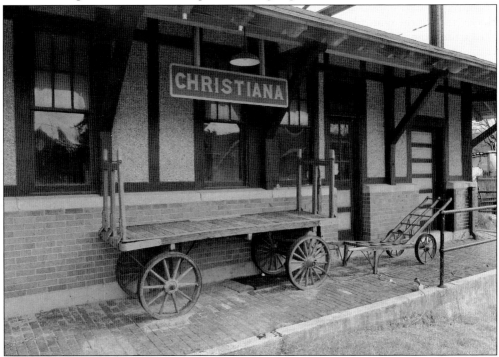

Nothing was more standard on the PRR (called the "Standard Railroad of the World") than the ubiquitous carts seen on the platforms of most vintage station photographs. Fortunately, two of them survive and are on display at the station in Christiana. Both handled luggage but the larger one, which could be pushed or pulled by two men, often handled small freight or bags of mail. The smaller one could be loaded with luggage and pushed right to an awaiting vehicle.

The image above is a reprint of an earlier, c. 1909 postcard image showing Gap Station in Salisbury Township. It was the second stop in Lancaster County and was named for the gap in Mine Hill through which the railroad was routed as seen on the map below. It has the distinction of being the highest point on the Main Line between Philadelphia and Harrisburg. A plan to realign the tracks into one long sweeping curve from a point south of Gap to just west of Kinzers was proposed in the 1930s, but the cost and impact on the land would have been extensive and the plan was shelved. (Below, US Geological Survey.)

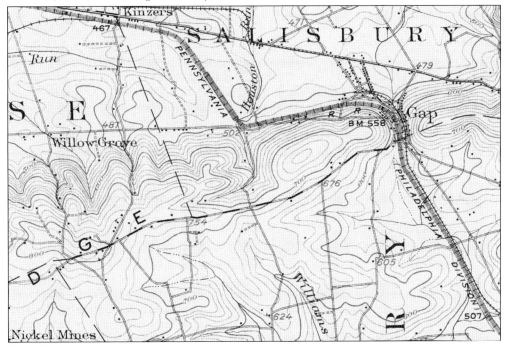

This early 1900s photograph shows the small station at Kinzers, the next stop after Gap. The station, along with several other buildings, was wedged on a narrow piece of land on the north side of the tracks between the Main Line and Lancaster Pike. The two buildings on the right still stand. Note the walkway across the tracks to board eastbound trains. (Courtesy of LancasterHistory. org, Lancaster, Pennsylvania.)

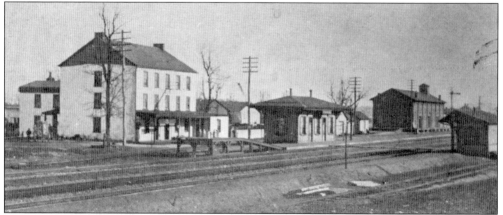

This view shows the Leaman Place Station area around 1900. Behind the main passenger station was the Leaman Place Hotel, which was also the area's first station for the P&C Railroad. The freight station in the background still stands. Leaman Place was the junction between the Pennsylvania and Strasburg Railroads. Passenger service on the Strasburg Railroad ended as a result of the automobile and competing streetcar service in the early 1900s, but freight service lasted into the 1950s. Since 1959, the Strasburg Railroad has been a popular tourist attraction. (Courtesy of LancasterHistory.org, Lancaster, Pennsylvania.)

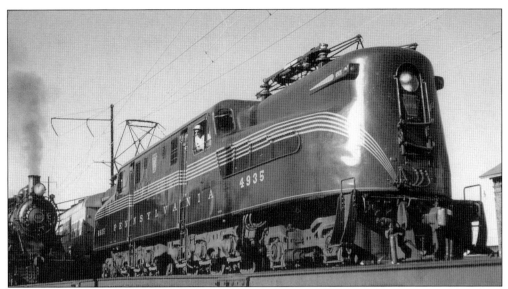

Locomotives pulling the Strasburg Railroad's excursion trains change ends at Leaman Place, and if the timing is right, a vintage steam engine can run parallel with an Amtrak train pulled by a high-horsepower electric locomotive. In this 1977 photograph, a recently restored GG1 poses with a Strasburg locomotive at Leaman Place.

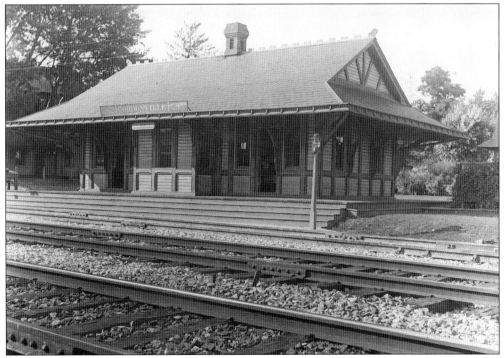

This c. 1900 image shows the small but stylish station in the village of Gordonville. It was built in 1889. Similar style stations were also built along the Main Line at Malvern, Pomeroy, and Gap. In the 1830s, Daniel Gordon built the first home in the area at the same time the Philadelphia and Columbia Railroad was being constructed. (Courtesy of LancasterHistory.org, Lancaster, Pennsylvania.)

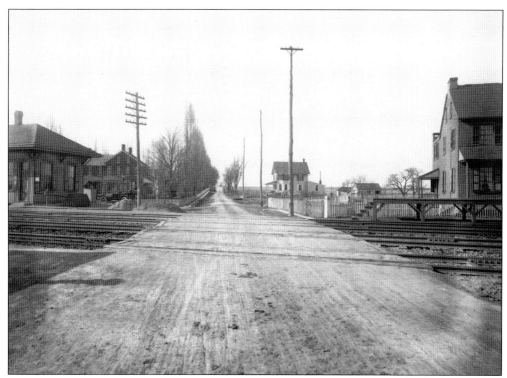

This photograph was taken in the early 1900s and shows the small station at Ronks (or Ronk) where the North Ronks Road crossed the tracks at grade. The station was built in 1883. Notice the platform on the right to handle local freight. Jesse P. Ronk owned a mill in this area. (Courtesy of LancasterHistory.org, Lancaster, Pennsylvania.)

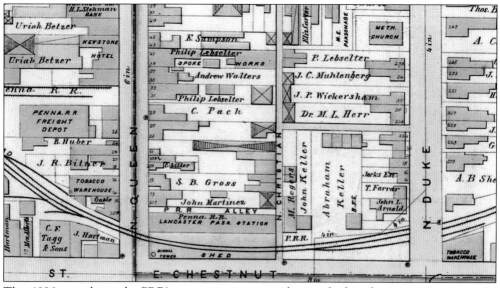

This 1886 map shows the PRR's passenger station and train shed in downtown Lancaster. In 1929, the station was moved almost a mile north out of the downtown area as a result of noise, congestion, and safety concerns. As a consequence, valuable railroad real estate opened up in the downtown area. (Courtesy of Penn State University.)

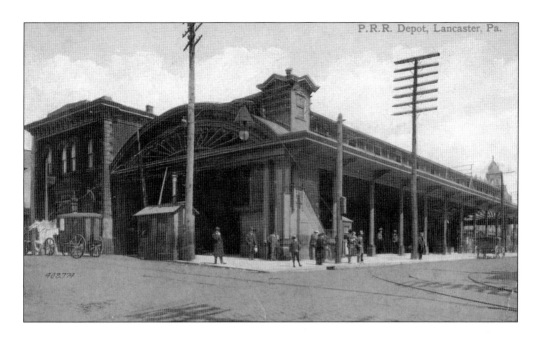

P.R.R. Depot, Lancaster, Pa.

These postcard views of the west end of Lancaster's train shed were both taken at the intersection of Queen and Chestnut Streets, but at different times in the early 1900s. The Express office is the building on the left. Note also the small shack where the crossing guard was located to protect pedestrians, carriages, and automobiles at what was probably a dangerous crossing. External stairs lead to the tower operator's office, which was constructed at some point after the station was built in 1860. In the above image, a water column that supplied locomotives can also be seen behind the carriage on the left.

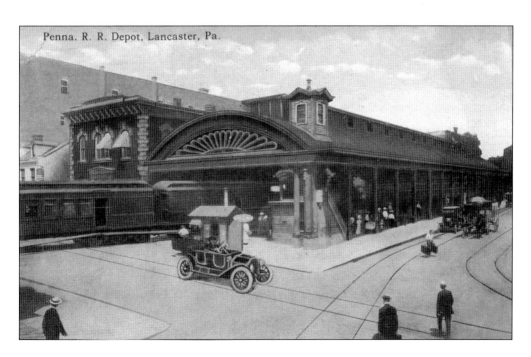

Penna. R. R. Depot, Lancaster, Pa.

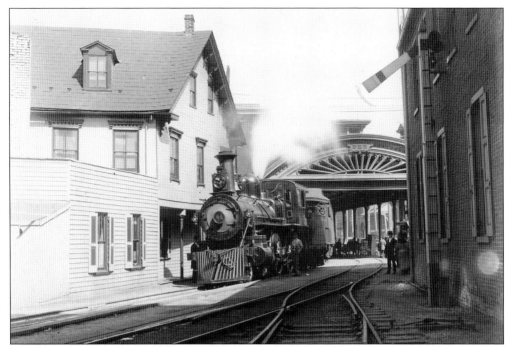

This photograph, probably taken about 1910, clearly shows the problem of running trains in downtown Lancaster. Blocked streets and large locomotives spewing steam and ash (literally within feet of homes and businesses) was a cause of much concern to residents. Although through trains were routed north of the city on a new cutoff in 1883, trains serving the city itself still needed to come downtown until the new station was built in 1929. (Courtesy of LancasterHistory.org, Lancaster, Pennsylvania.)

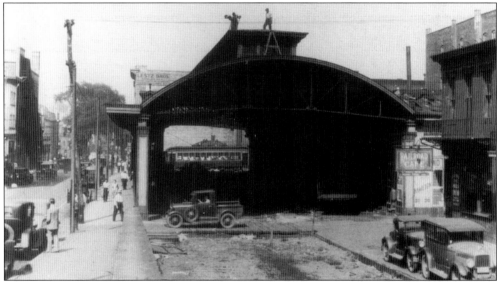

Soon after the last train left Lancaster's downtown station on April 28, 1929, the tracks were torn up and demolition of the train shed began. Seen in the background is a trolley running on North Queen Street. The new Lancaster Station was less than a mile north (right) on North Queen Street. Notice the sign for the Railroad Café.

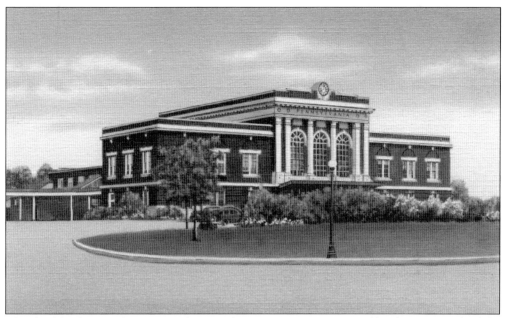

The third (and current) station in the city of Lancaster was constructed by the PRR north of the downtown area in 1929 at a cost of $1,500,000. It is seen in this postcard image soon after it was built. This is Amtrak's busiest station on the Keystone Line west of Philadelphia.

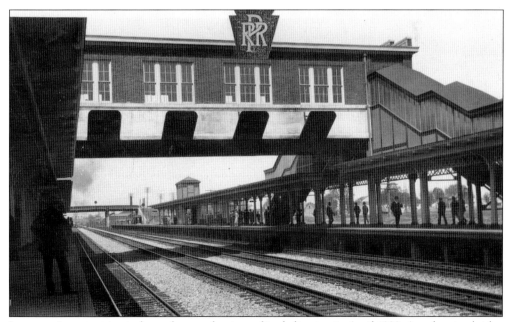

Lancaster's new station is shown here at the time of its dedication in April 1929. A pedestrian bridge allows access to the high-level platforms. The center tracks were part of the original Lancaster cutoff and were used for freight trains bypassing the city. These center tracks have since been removed. (Courtesy of LancasterHistory.org, Lancaster, Pennsylvania.)

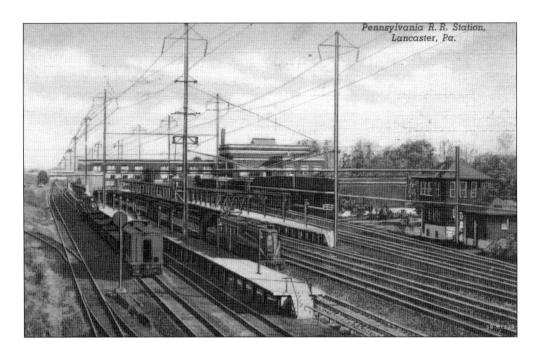

The pedestrian bridge connecting the station building to the platforms at Lancaster Station are seen in these two images taken about 75 years apart. The view in the postcard image above from the late 1930s or early 1940s looks east and shows a passenger train pulled by a new GG1 locomotive heading west toward Harrisburg, while a work train pulled by a steam locomotive is on the left. At right is Cork Tower, which was built at the same time as the station in 1929 and controlled the train movements in the area. In the modern view below looking west, an eastbound Keystone train leading with a cab car just pulled into the station on a midmorning run. Notice there are 10 tracks going past the station in the older image. Today, there are just four.

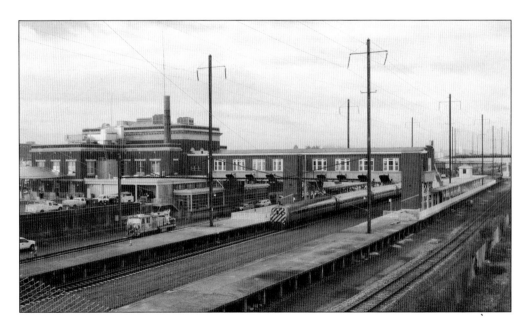

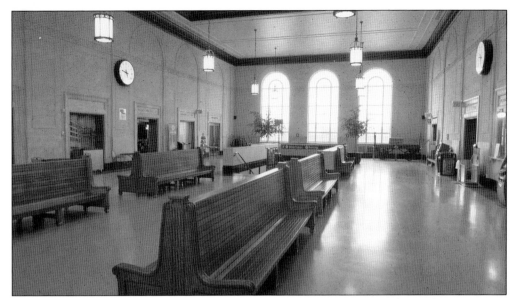

In 2014, a multiyear project was completed at Lancaster Station after years of deferred maintenance. Both the interior and exterior were completely refurbished along with expanded parking and landscaping. This is the main waiting area with large Palladian windows facing south towards downtown Lancaster.

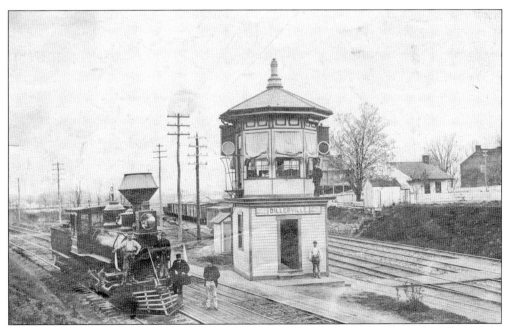

Just west of Lancaster, railroad workers pause for a photograph at Dillerville. Dillerville was the junction of the PRR Main Line (to the right) and Columbia Branch (to the left) and over time would become a busy and complicated system of tracks. This 1880s view shows the combination tower and station. Note the type of signals being used, which were new at the time. (Courtesy of LancasterHistory.org, Lancaster, Pennsylvania.)

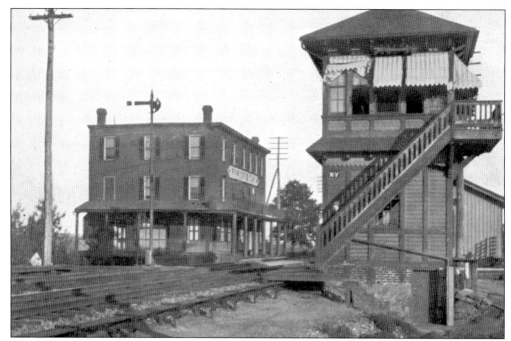

The combination station and hotel is shown in a 1909 photograph of Landisville. In 1870, the Methodist Church chose Landisville as the permanent location for its annual camp meeting, not only for the beautiful location and ample supply of water, but also for its proximity to transportation, including the Main Line. During some years, the PRR had all through trains stop at Landisville during the annual meeting and even ran special trains from Harrisburg. (Courtesy of LancasterHistory.org, Lancaster, Pennsylvania.)

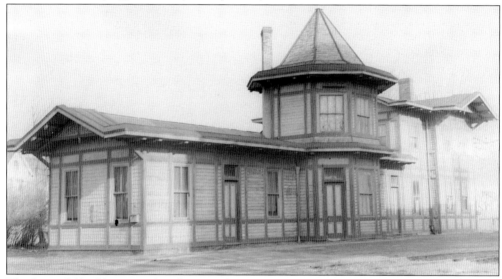

This beautiful building served as the second passenger station in the Borough of Mount Joy. Built in 1876, it replaced the station that was located in the Exchange Hotel, which was the original station for the Harrisburg and Lancaster Railroad. In 1896, the PRR realigned the tracks through town and a new station was constructed two blocks south. The building was eventually demolished. (Courtesy of LancasterHistory.org, Lancaster, Pennsylvania.)

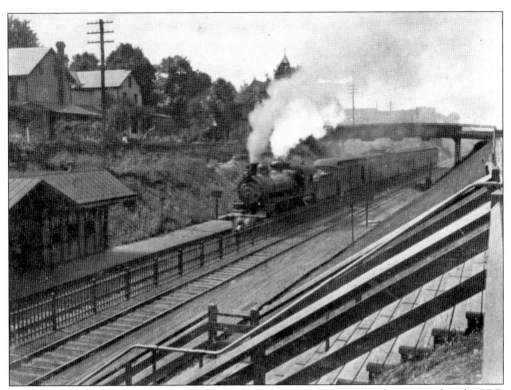

The Mount Joy cutoff was one of the few track improvements completed in 1896 after the PRR suspended most projects due to an economic depression. While the cutoff leveled and straightened the tracks, it resulted in the tracks running below street level through a cut in the middle of town. The above photograph was taken on the north side of the tracks where the main station was located as the eastbound Seashore Express steams into town. Note the steep stairs going down to the tracks. These same stairs are seen in the below photograph of Mount Joy Station taken in the early 1970s before it was torn down.

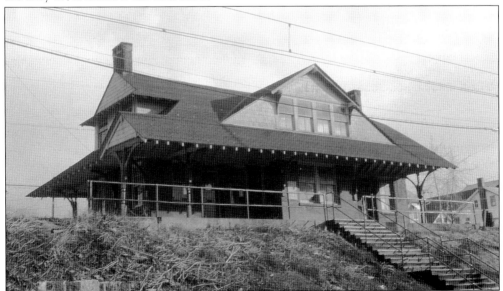

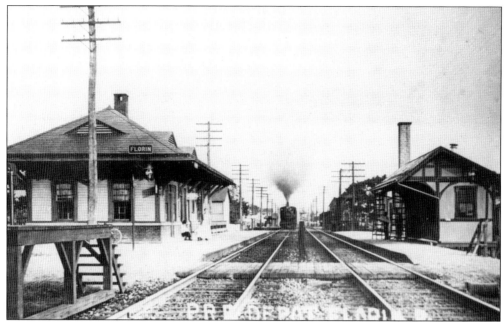

About a mile past Mount Joy was the small hamlet of Florin, which was also known as Springville in earlier years. The photographer took this eastbound view as a train steams into the station. Like most rural stations, Florin had a platform (seen at left) for the daily milk train. There also appears to be a bicycle leaning against the side of the station. (Courtesy of LancasterHistory.org, Lancaster, Pennsylvania.)

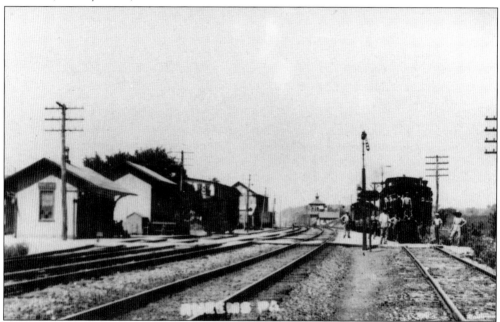

A few miles before Elizabethtown is the community of Rheems. On the left are the small passenger station, freight station, and several other businesses. A freight train stands on the siding at right where at least a dozen men wait for the photographer to take the picture. (Courtesy of LancasterHistory.org, Lancaster, Pennsylvania.)

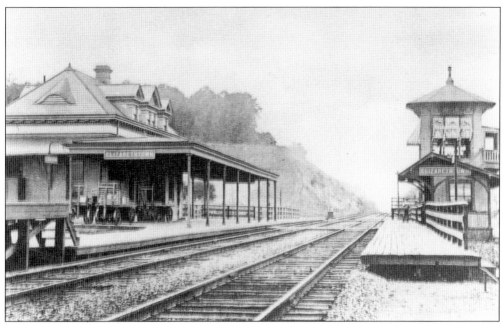

The PRR built this station at Elizabethtown in 1900. The switching tower on the other side of the tracks at the westbound platform was built a few years later. The railroad cut seen beyond the station was once a tunnel but the roof of the tunnel was removed in 1875. The station at Middletown was of a similar design to this one. (Courtesy of LancasterHistory.org, Lancaster, Pennsylvania.)

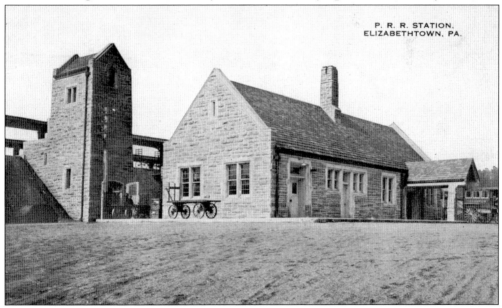

This c. 1915 postcard view shows the newly constructed station at Elizabethtown, which replaced one built only 15 years earlier. The tall structure is a baggage elevator. Note the two trunks that were either just taken off a train or are awaiting delivery to the platform. Unlike other smaller stations along the Main Line, Elizabethtown was constructed out of limestone and its architecture was intended to mimic other structures in the borough. During a summer night in 1919, thieves broke into the Elizabethtown Station and dynamited the safe. The total take was about $150.

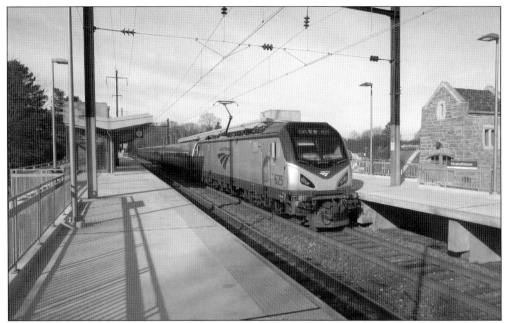

A westbound Amtrak Keystone train just pulled into the Elizabethtown station with the engine in the trailing position (pushing the train) in this recent image. Between 2009 and 2011, Elizabethtown underwent a complete renovation. In addition to the remodeling of the station building, high-level platforms and new canopies were installed. The old baggage elevator can be seen on the right.

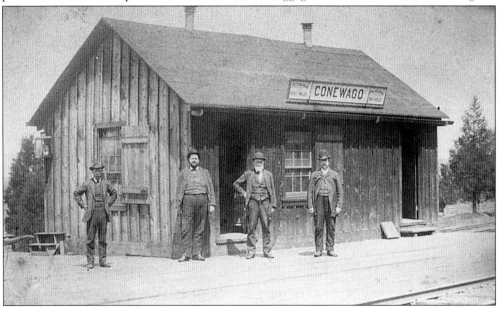

Four men stand for the camera outside the first Conewago station around 1885. Conewago was the westernmost station in Lancaster County. In 1900, a PRR track inspector at Conewago was hit by a freight train and "hurled from the tracks" when he sat down on the tracks to rest and fell asleep. Thinking he was seriously injured, the train crew picked him up and brought him to a hospital in Harrisburg. Fortunately, his injuries were relatively minor and he was released within a week.

Nine

DAUPHIN COUNTY

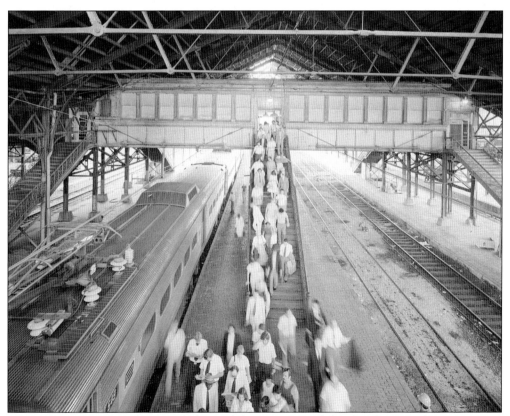

Passengers in this 1981 photograph descend the stairs to track level at the Harrisburg Station to an awaiting eastbound Amtrak train. At this time, Amtrak was operating its Silverliner Service between Philadelphia and Harrisburg with 14 round-trips each weekday. It was leasing train cars from SEPTA that still bore the Penn Central logo. Only two Dauphin County stations are still in use on the Main Line (Middletown and Harrisburg). At one point, there were as many as 10. (Courtesy of Library of Congress.)

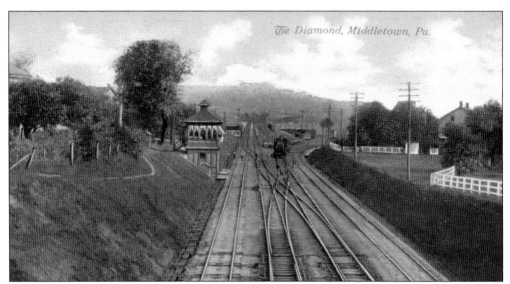

This c. 1908 postcard view taken in Royalton (just south of Middletown) faces east and shows the interchange of the PRR's Columbia Branch coming from the right and the Main Line. The tower on the left controls the train movements between the two lines. Visible just beyond the tower was the station called Branch Intersection. In 1914, the name of the station was officially changed to Royalton at the behest of the town's council, whose members thought that "Branch Intersection creates an impression that the town is only a small village."

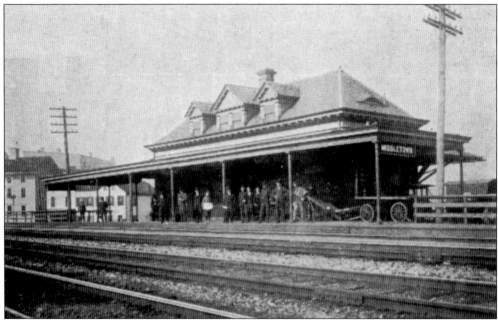

A group of passengers poses for the photographer while waiting for a train at Middletown Station around 1909. The station was built in 1903 and replaced an older one on the west side of town. This former station was itself moved in 1888 from the center of Middletown as a result of a dispute between the railroad and borough officials. According to one account, "the structure was placed upon trucks and taken to its present location with as little trouble as the removal of a chicken coop on a wheelbarrow."

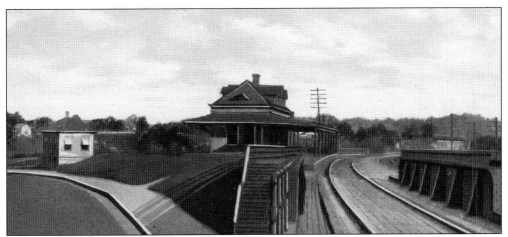

This postcard view facing east shows the Middletown Station around 1908. The photographer was standing on the Union Street Bridge. Mill Street is at right. About 50 yards north (left) was the station for the Middletown and Hummelstown branch of the Philadelphia and Reading Railroad.

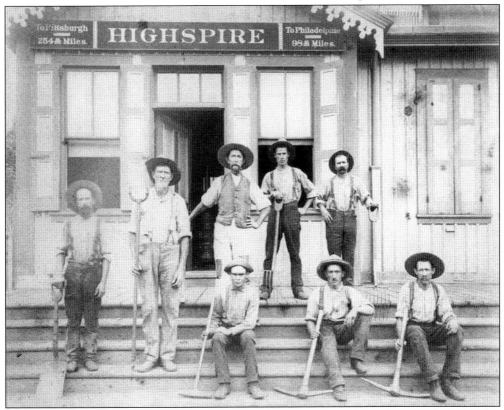

This group of railroad laborers must have been working nearby when the photographer set up his camera at the small station at Highspire around 1900. Highspire is located on the Susquehanna River between Middletown and Harrisburg. Notice the assortment of railroading tools among the group. Like many stations along the Main Line at the time, there was a standard station sign with the mileages to Philadelphia and Pittsburgh. A potbelly stove can be seen through the station door. (Courtesy of Highspire Historical Society.)

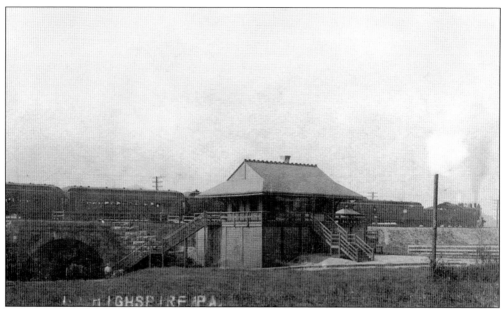

After a flood in 1904, the PRR moved the tracks through Highspire closer to the Susquehanna River, though on an embankment above the flood line. The view in the above photograph faces west and shows a passenger train on the new embankment, beyond which is the Susquehanna River. Note the passenger station was elevated above the flood line too. Latticework covers the support structure for the station. The below photograph of the station was taken from the tracks, and the view faces east towards the town of Highspire. An elevated walkway connects the station to the tracks. The station is long gone, but the stone-arch underpass seen above still gives local residents access to the river. (Both, courtesy of Highspire Historical Society.)

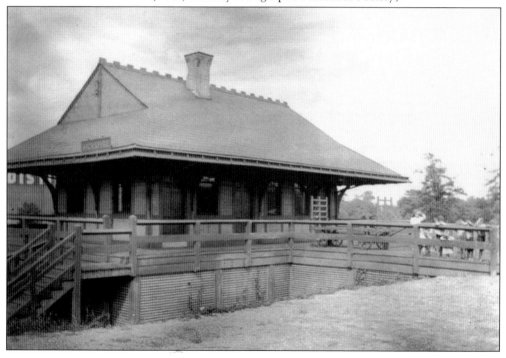

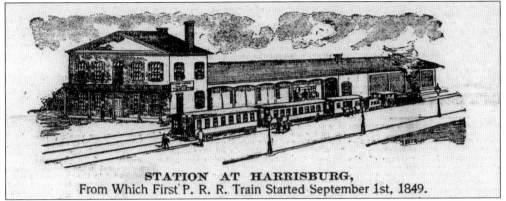

STATION AT HARRISBURG,
From Which First P. R. R. Train Started September 1st, 1849.

Harrisburg's first train station (as seen in this drawing) was constructed in 1837 and was the first station ever used by the PRR. The two-story office structure on the end of the building was added at a later date. The station was torn down in 1856 to make way for a much larger facility.

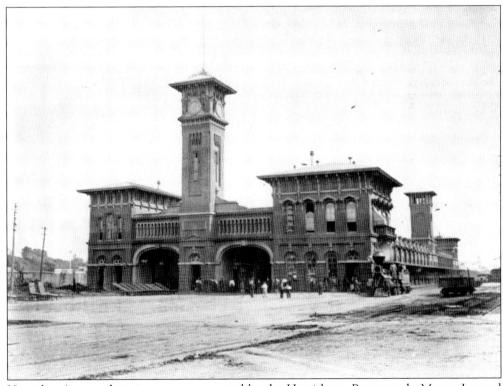

Harrisburg's second station was constructed by the Harrisburg, Portsmouth, Mount Joy and Lancaster Railroad in 1857 but leased to the PRR. The tower in the center was 72 feet high and was used as an observation point to spot approaching trains. The station only lasted 30 years before being replaced by the current one in 1887. (Courtesy of Library of Congress.)

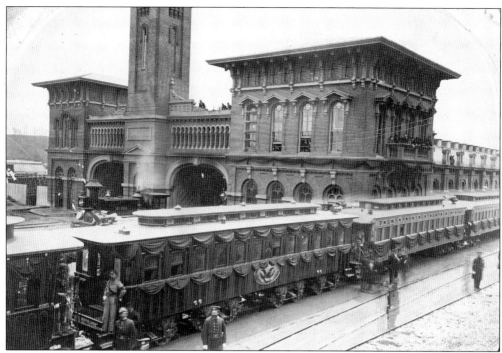

Harrisburg was the first overnight stop for Lincoln's funeral train after it left Washington, DC, on April 21, 1865. The train reached Harrisburg about 8:00 the night of April 21 and left the next day at 11:15 a.m. for its next official stop at Philadelphia. While in Harrisburg, Lincoln's coffin was taken to the capitol building, where thousands of mourners paid their last respects. The time is not visible on the clock tower in the photograph below, but both images were probably taken late in the morning of April 22, 1865, before the train left for Philadelphia. The station of the Philadelphia and Reading Railroad is visible in the background below and is adorned with black crepe and a flag at half-staff. There probably was no more room on the station balcony, so two men decided to sit on the station roof to watch the train leave, as seen above. (Courtesy of Pennsylvania State Archives.)

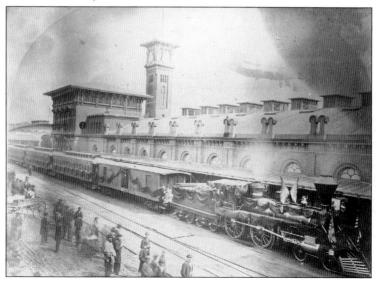

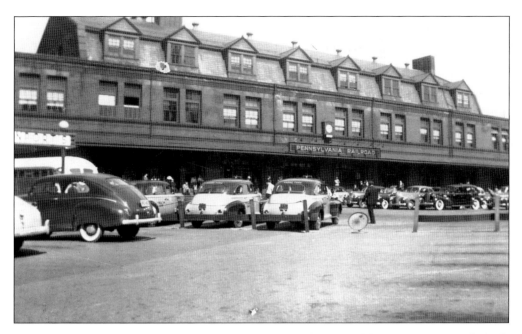

The third (and current) station at Harrisburg is seen in the 1940s (above) and in 1981 (below). The station was built in 1887 and renovated following a fire in 1904. It is a designated National Historic Landmark and was listed in the National Register of Historic Places in 1975. In the early 1900s, more than 100 trains per day went through the station, in addition to trains that went to and from the nearby Reading and Cumberland Valley Railroads' stations. Today, there are 28 Amtrak trains each weekday at Harrisburg. Many Pennsylvania state workers use Amtrak to commute to work each day from all Amtrak stops along the Main Line. Several bus lines also use the station as a stop. The building is owned by Amtrak but operated by the Harrisburg Redevelopment Authority. (Below, courtesy of Library of Congress.)

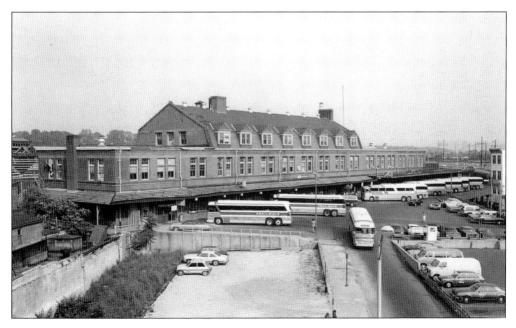

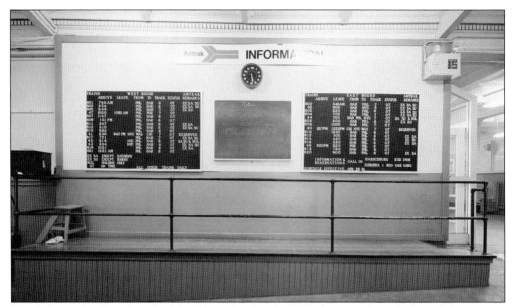

The information board at the Harrisburg Station in 1981 shows train arrivals and departures. Fourteen trains ran on weekdays in each direction (28 total)— the same number as today. However, most trains today go to and from New York City and each has more cars than those running in 1981. The Broadway Limited still ran at this time between New York and Chicago. (Courtesy of Library of Congress.)

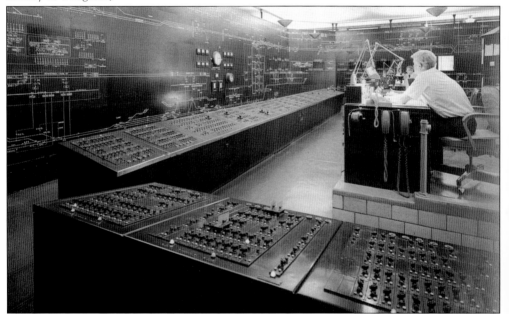

A power director's room was located at the Harrisburg Station as seen in this photograph from 1981. This was the control center for the distribution of electrical power to signals and the overhead track wires (catenary). The model board on the wall represents the length of the Main Line from Harrisburg (on the left) to Thorndale (on the right). The model board shows the electrical infrastructure including high-voltage lines, switches, circuit breakers, and substations. (Courtesy of Library of Congress.)

BIBLIOGRAPHY

Alexander, Edwin P. *On The Main Line, The Pennsylvania Railroad in the 19th Century.* New York, NY: Bramhall House, 1971.

Bell, William A. "Paoli Local." *Trains Magazine* (February 1947): 14–17.

Guide for the Pennsylvania Railroad. Philadelphia, PA: T.K. and P.G. Collins, 1855.

Messer, David W. *Triumph II, Philadelphia to Harrisburg 1828–1998.* Baltimore, MD: Barnard, Roberts and Co. Inc., 1999.

Pennsylvania Railroad List of Stations and Sidings, The. Philadelphia, PA: Pennsylvania Railroad, 1941.

Pictorial Review of Progress on the Pennsylvania, A. March 1953.

Pinkowski, Edward. *Chester County Place Names.* Philadelphia, PA: Sunshine Press, 1962.

"Plans for Pennsy's New West Philadelphia Depot." *Philadelphia Inquirer.* September 24, 1901.

"Results of the Elevated Line." *Philadelphia Times.* June 18, 1882.

Sipes, William B. *The Pennsylvania Railroad: Its Origin, Construction, Condition, and Connections.* Philadelphia, PA: Passenger Department, 1875.

Suburban Stations and Rural Homes on the Pennsylvania Railroad. Philadelphia, PA: Office of the General Passenger Agent, 1875.

Wilson, William Bender. *History of the Pennsylvania Railroad Company.* Philadelphia, PA: Henry T. Coates and Company, 1899.

DISCOVER THOUSANDS OF LOCAL HISTORY BOOKS FEATURING MILLIONS OF VINTAGE IMAGES

Arcadia Publishing, the leading local history publisher in the United States, is committed to making history accessible and meaningful through publishing books that celebrate and preserve the heritage of America's people and places.

Find more books like this at
www.arcadiapublishing.com

Search for your hometown history, your old stomping grounds, and even your favorite sports team.